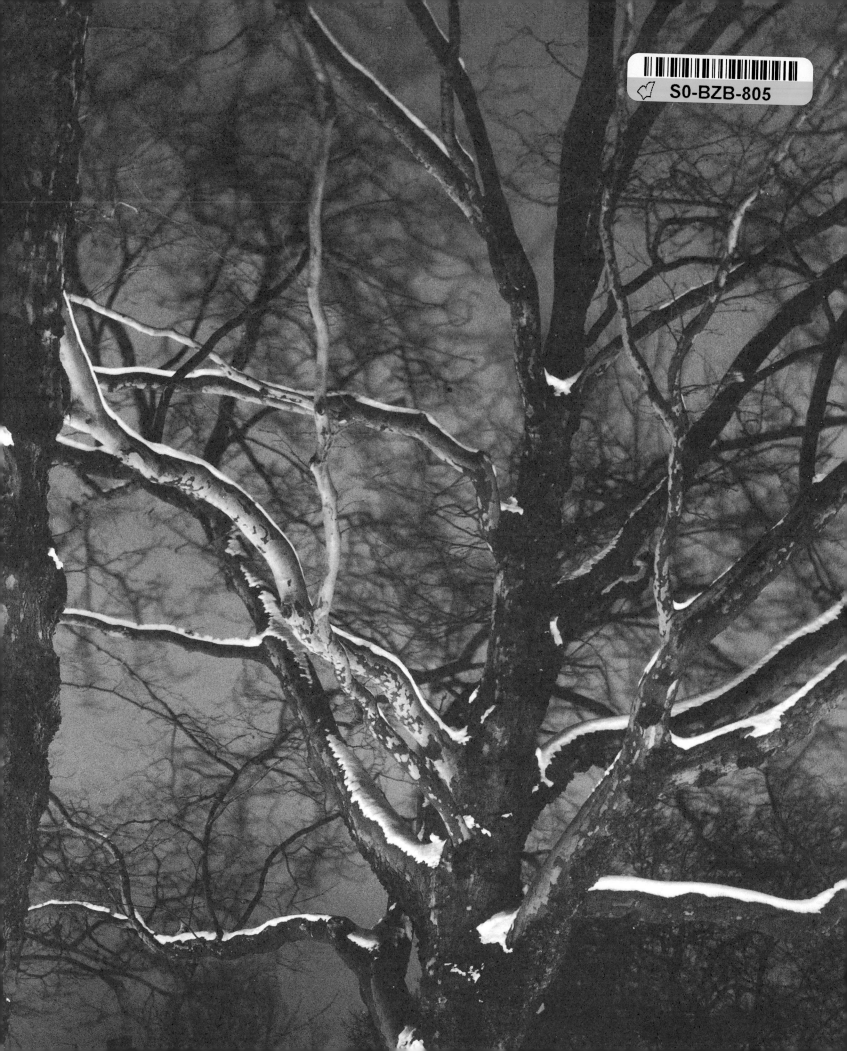

London After Dark

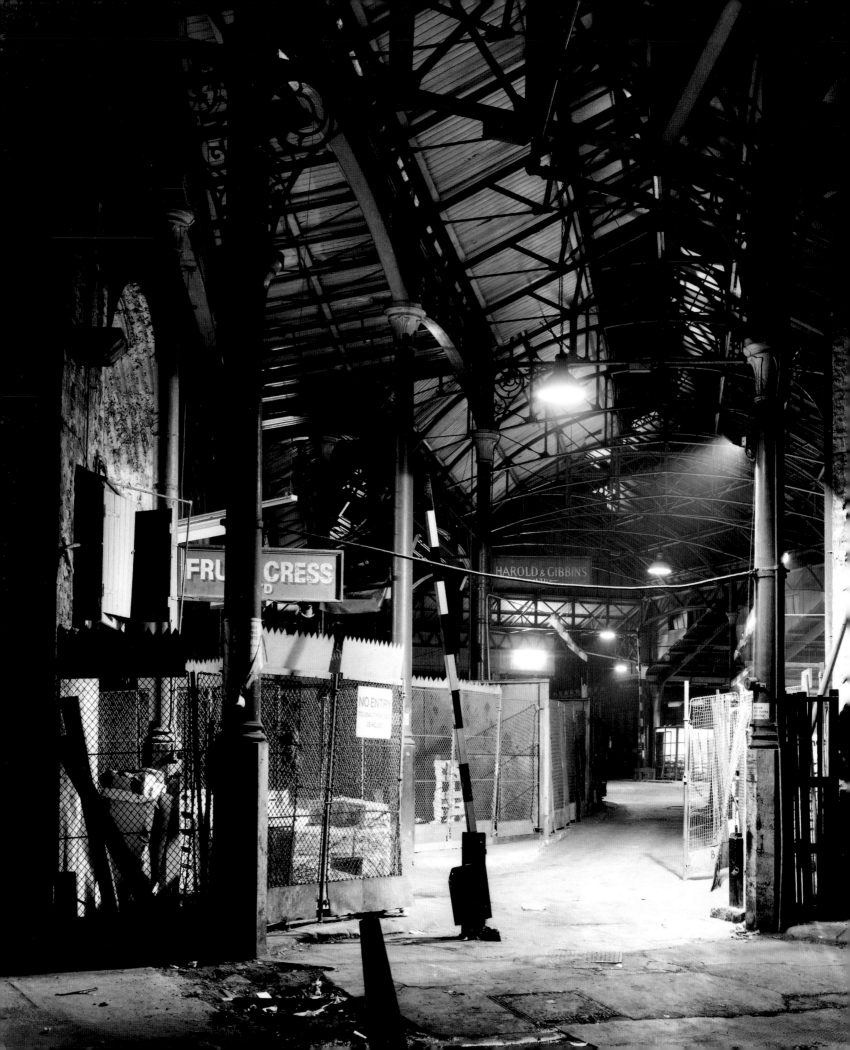

London After Dark

Photographs by Alan Delaney Commentary by Robert Cowan

To Jack, Andrew and Jessica

Borough Market,
Southwark
(frontispiece)

Old Street
and the City of London

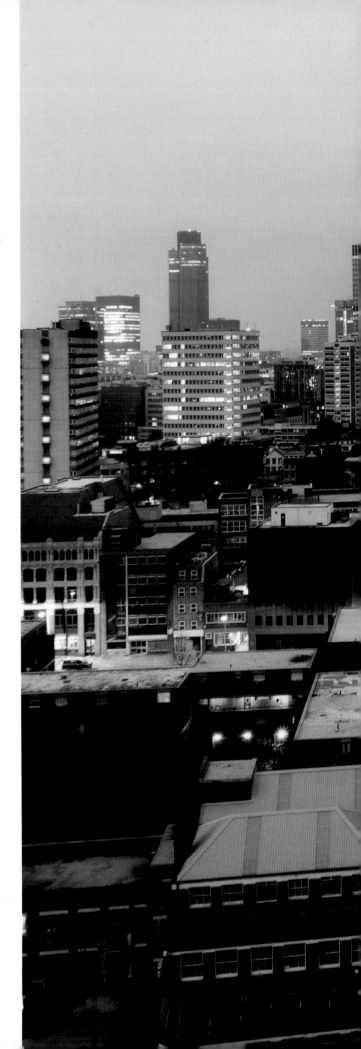

Phaidon Press Ltd
140 Kensington Church Street
London W8 4BN

First published 1993

© 1993 Phaidon Press Limited
Photographs © 1993 Alan Delaney

ISBN 0 7148 2870 X

A CIP catalogue record for this book is available from
the British Library.

Printed in Hong Kong

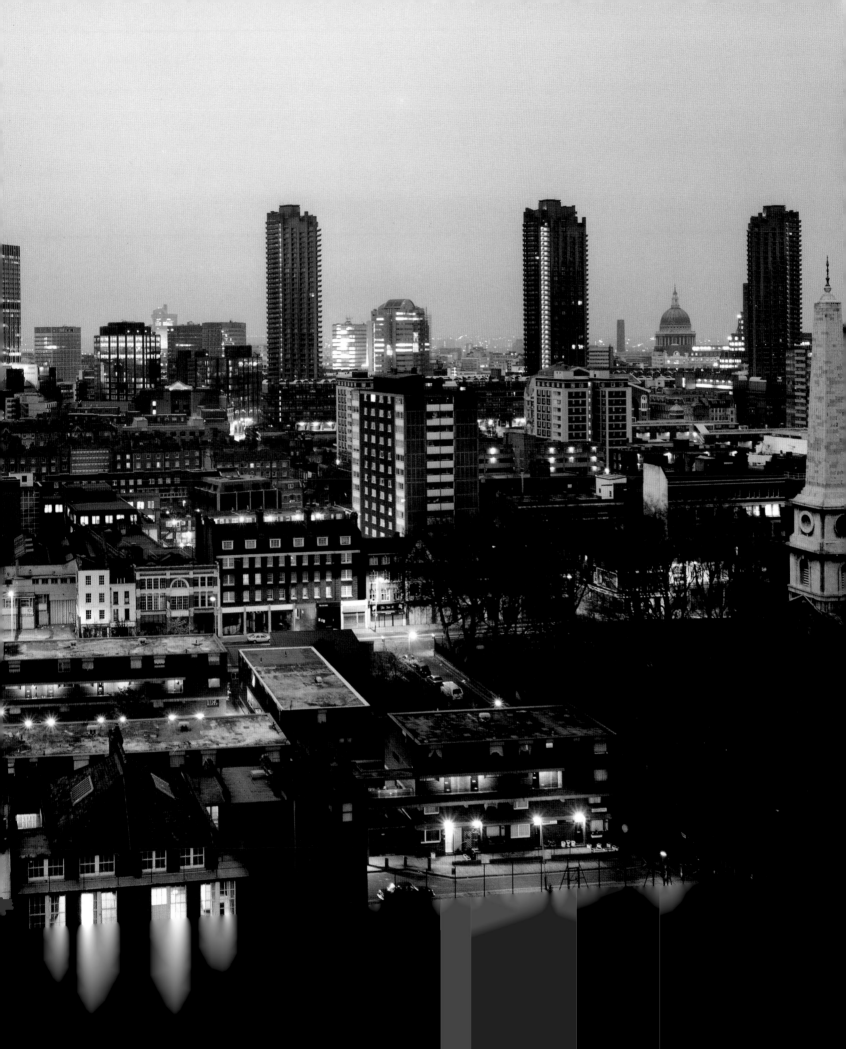

The streets are empty.

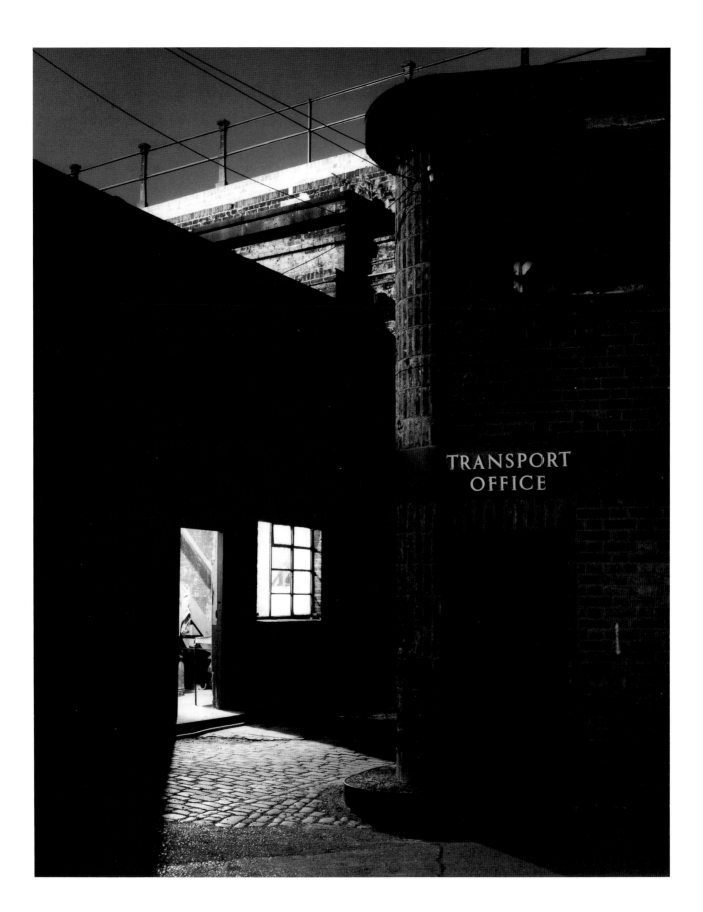

Only rarely does a figure remain still long enough to mark the negative on the camera's long exposure: a train driver writing up his log, a man watching from an upstairs window, a few people at a funfair waiting for a firework display to begin, a drunk crumpled on the pavement. Alan Delaney's photographs show what generations of Londoners have created: the manifestations in brick, stone, concrete and steel of the life of a great city – of hopes, dreams, genius, generosity and greed, pomposity and piety.

London is indescribably diverse. How people experience it depends on their mood, their interests and how they fit into the human networks that form the web of city life. Living in such a place is an art. Jonathan Raban advised in *Soft City* (1974):

> Decide who you are, and the city will again assume a fixed form round you. Decide what it is, and your own identity will be revealed, like a position on a map fixed by triangulation. Cities, unlike villages and small towns, are plastic by nature. We mould them in our images: they, in their turn, shape us by the resistance they offer when we try to impose our own personal form on them. In this sense, it seems to me that living in cities is an art, and we need the vocabulary of art, of style, to describe the peculiar relationship between man and material that exists in the continual creative play of urban living.

Alan Delaney has spent ten years discovering London by night. Most people explore their city when its people are up and about, but he is attracted by the night-time peace and quiet. 'The tubes stop, the crawling traffic is replaced by the occasional speeding car, and the ground stops shaking,' he says. 'For me that is the best time to seek out the beauty of the place.'

In roaming London he has found much to upset and depress him, but that is not what he wishes to share through his photographs. 'There's plenty of mess and confusion,' he says. 'London can be uniquely horrendous. But I find many textures and patterns, forms and structures to love.' The photographs in this book are not intended to present a comprehensive portrait of the capital: they are a personal choice of subjects that have attracted Delaney on his night-time wanderings.

We each create our own image of London from fragments we know and according to the circumstances we know them in. For some Londoners the experience is limited and repetitive, a dull

Transport Office, Limehouse Basin

The end of another day at the office; under the arches of the former London and Blackwall Railway at Limehouse Basin, where the Grand Union Canal joins the Thames. The trains, which ran between the City and the docks, were originally dragged by cable, appropriately, as the line runs parallel with Cable Street, where cables were made. Cable Street is better remembered as site of the 'battle' of 5 October 1936, when the police fought with local people who had erected barricades to prevent a march by Sir Oswald Mosley and his fascist Blackshirts. The march was abandoned and in the following days hundreds of Jewish shops in the area had their windows smashed. The viaduct now carries the Docklands Light Railway.

routine of home, shopping and journey to work, 'Living amid the same perpetual whirl/ Of trivial objects, melted and reduced/ To one identity ...', as Wordsworth grimly observed. Others experience its worst horrors: the children who sleep rough; the frightened victims of racial abuse; those who barricade themselves into their flats at night against the threat of burglary; and the poor who in a city of variety have no choice at all. Others enjoy the best that London has to offer.

At night the city appears, literally, in a new light: floodlight brilliantly illuminating what by day the sun casts in shadow; harsh, slanting streetlight; or pale moonlight. The transformation can liberate the imagination from the mundane. Thomas Carlyle saw night smiling on the poorest and filthiest of the buildings of Victorian London. 'They lose themselves in the dim sky and the tall chimneys become campanili, and the warehouses are palaces in the night, and the whole city hangs in the heavens,' he wrote. To Stephen Graham, writing in *London Nights* (1925), 'London at night speaks to the heart, telling its dreams of humanity that has passed, whispering melancholy stories to the melancholy and strange thoughts to the stranger.'

London by moonlight in the wartime blackout – the subject of a memorable series of photographs by Bill Brandt – was recalled by William Sansom in 1947. 'A city bereft of electric and neon light,' he wrote, 'took on a new beauty – by moonlight the great buildings assumed a remote and classical magnificence, cold, ancient, lunar palaces carved in bone from the moon; and angular overdressed Victorian eccentricities were purified, uncoloured, quietened by the moon's ubiquitous sanity.'

Such perceptions are more than a trick of the light. Ford Madox Ford (or Hueffer as he then was) wrote in *The Soul of London* (1905) that:

> To enter London with the market wagons in the darkness before dawn was to be not awed by an immense humanity but disturbed by entering what seems some realm of the half supernatural ... All the vacant blinds, the sinister, the jocular, the lugubriously inquiring, or the lamentable expressions that windows give to houses asleep, all the unsmoking chimneys, the pale skies, and the thought of all these countless thousands lying invisible, with their souls, in sleep, parted from their bodies – all these things give an effect, in its silence, immense, stealthy, and overpowering.

Cheshire Street, Spitalfields Despite the air of dereliction, these streets accommodate one of London's largest and busiest Sunday markets. At four o' clock in the morning the dealers are trading; by eight o'clock the stalls are open and the crowds are out looking for bargains.

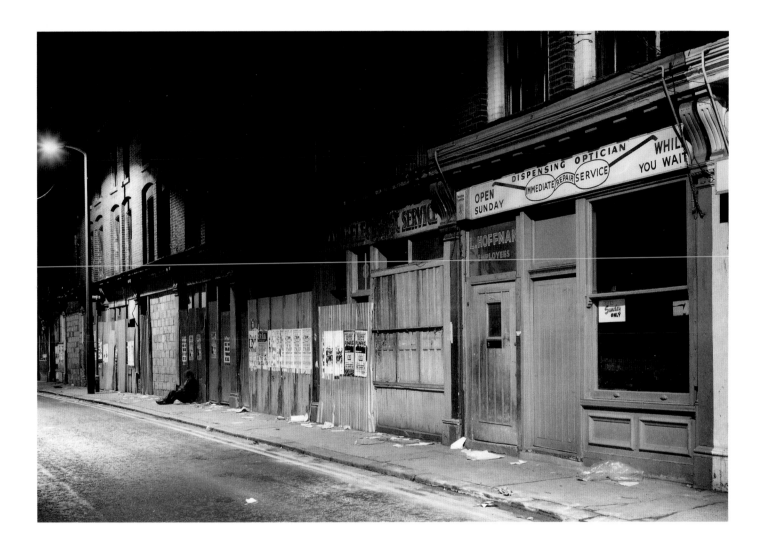

In the silence of the night the city speaks for itself. No one listened more attentively than Charles Dickens, who as much as anyone has shaped Londoners' response to the dark side of their city. The lowest point of Dickens' early experience of London was as a 12-year-old working in a blacking factory, his father imprisoned for debt. The London of his imagination always remained a place where fear and degradation lay just around the corner. The darkness of fog or night served in his novels as the element in which evil flourished, and which might swallow innocence at any moment. In *Oliver Twist*, Fagin is its personification. 'As he glided stealthily along, creeping beneath the shelter of the walls and doorways, the hideous old man like some loathsome reptile, engendered in the slums and darkness through which he moved: crawling forth, by night, in search of some rich offal for a meal.'

Even in the daytime, even without fog, Dickens' London might become engulfed in darkness. *Bleak House* evokes:

> Implacable November weather. As much mud in the streets, as if the waters had but newly retired from the face of the earth, and it would not be wonderful to meet a Megalosaurus, forty feet long or so, waddling like an elephantine lizard up Holborn Hill. Smoke lowering down from chimney-pots, making a soft black drizzle with flakes of soot in it as big as full-grown snowflakes – gone into mourning, one might imagine, for the death of the sun. Dogs, undistinguishable in mire. Horses, scarcely better; splashed to their very blinkers. Foot passengers, jostling one another's umbrellas, in a general infection of ill temper, and losing their foothold at street-corners, where tens of thousands of other foot passengers have been slipping and sliding since the day broke (if this day ever broke), adding new deposits to the crust upon crust of mud, sticking at those points tenaciously to the pavement, and accumulating at compound interest.

This habitat of the elephantine lizard or the reptilian Fagin was a city transformed. Dickens moulded it as the raw material of his fiction, calling up his own and his readers' dreams and nightmares. The trick worked – and works still – because London is so huge and hard to comprehend. Our image of the city is bound to be at least in part a product of the imagination, and we are all suggestible.

The dark side of the sleeping city has fascinated writers both before Dickens and since. Richard Aldington's *Death of a Hero* (1929) takes two characters for a moonlit walk on the embankment. When eventually they turn to go home:

> In front of them ran the mystically lovely river; behind them the dark masses of the Temple rose solidly and sternly defensive of Law and Order behind the spear-front of its tall sharp-pointed iron fence. And there they crouched and huddled in rags and hunger and misery, free-born members of the greatest Empire the earth has yet seen, citizens of Her who so proudly claimed to be the wealthiest of cities, the exchange and mart of the whole world.
>
> George gave what change he had in his pockets to a noseless syphilitic hag, and Elizabeth emptied her purse into the hand of a shivering child which had to be awakened to receive the gift, and cowered as though it was going to be struck.

St Pancras station For a few years the Midland Railway shared the Great Northern's modestly economical King's Cross station. For its own terminus, built in 1863-67, its engineer William Henry Barlow created something much more spectacular. The single-span roof is the widest station roof in Europe and the highest in the world, its arch rising to a gentle Gothic point 100 feet above the tracks. At the other end of the station is the Midland Grand Hotel, that extravagant Gothic confection which its architect Sir George Gilbert Scott thought was 'possibly too good for its purpose'. The new station arose from a sea of destruction: the homes of some 10,000 people were demolished to make way for it. Many of them were slums, which allowed the railway company to claim credit for removing a social evil. In reality the displaced residents had little option but to increase the levels of overcrowding in houses of equally appalling standard elsewhere. British Rail plans to remodel St Pancras as the terminus for the Channel Tunnel rail link.

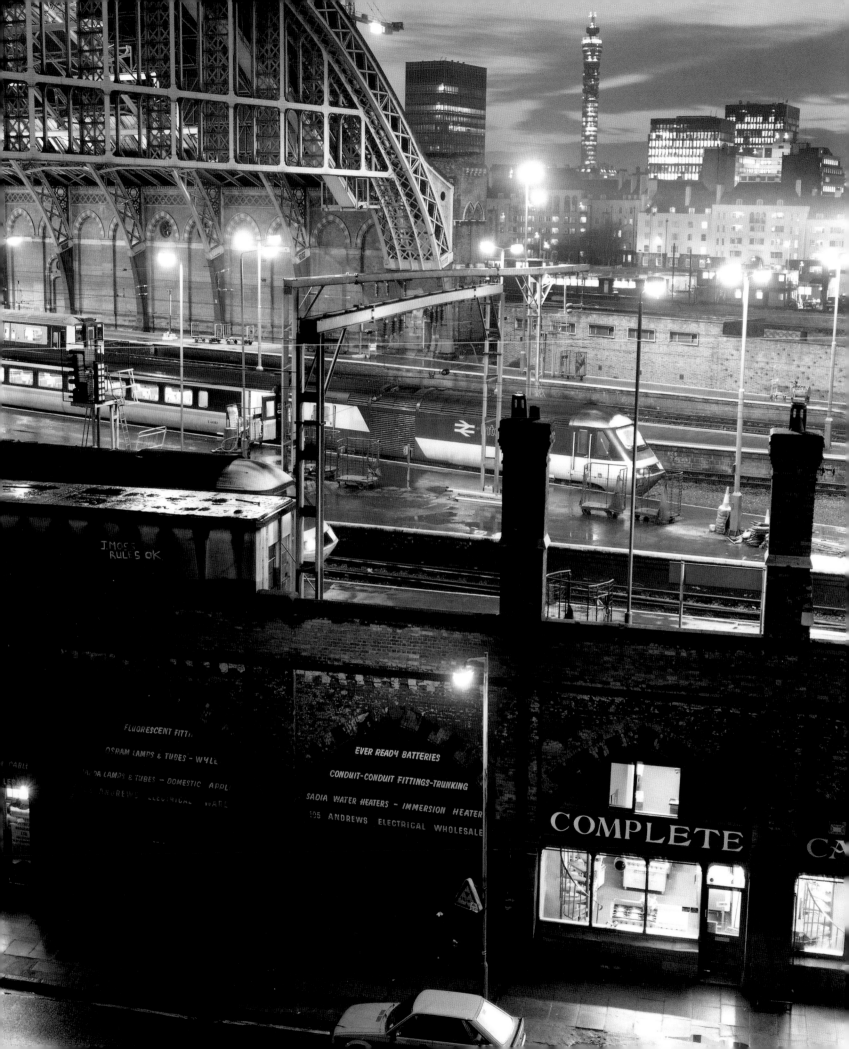

The 'noseless syphilitic hag' and her equivalents were also stalwarts of the many books intended to evoke London's hidden horrors for purposes of edification or titillation. 'It is when the lights of London begin to glow', declared ex-Detective Superintendent Robert Fabian in *London After Dark* (1954), 'that the denizens of the underworld of vice engage in their nefarious trades.' To an experienced policeman they were easy to recognize: a gunman, Fabian explained, was always slender with grey eyes. Such confidence in stereotypes is chilling.

In 1869 J. Ewing Ritchie warned in his book *The Night Side of London* of, 'the vile crew who earn an infamous livelihood by pandering to all that is degraded in man and woman – whose vulture eyes follow you up and down, and who, if they could, would rob you of your last farthing, and tear from off your back your last rag.' Londoners weakened by the capital's impure food – 'water in the milk, rice and alum in the bread, turmeric in the mustard ...' – would be ripe for temptation, the sanctimonious Ritchie warned. Furthermore, 'give every public house or beer shop in London an average frontage of 21 feet, and we shall find, if placed side by side, they would make a row of houses 39 miles in length'. Ritchie's purpose was to make manifest what he saw as London's appalling infrastructure of temptation.

Some people would be miserable whatever the city offered. The poet James Thomson was one of them. A solitary resident of dreary rooms in Pimlico and Bloomsbury until he died of drink at the age of 48, 'he walked about London in frayed bedroom slippers in the winter night by the gas flares,' according to Geoffrey Grigson. Thomson portrayed his own personal hell in the long poem *The City of Dreadful Night* (1874), in which the city's clamour made feelings of isolation all the more poignant:

The City is of Night, but not of Sleep;
There sweet sleep is not for the weary brain;
The pitiless hours like years and ages creep,
A night seems termless hell. This dreadful strain
Of thought and consciousness which never ceases,
Or which some moment's stupor but increases,
This, worse than woe, makes wretches there insane.

Herman Melville, an American visitor to London, hinted at such insanity in his novel *Redburn* (1849). In a chapter describing 'A Mysterious Night in London', Redburn visits, not some dive where

the poor drown their sorrows, but a magnificent gambling house. 'Yet I was mysteriously alive to a dreadful feeling, which I had never felt before, except when penetrating into the lowest and most squalid haunts of sailor iniquity in Liverpool. All the mirrors and marbles around me seemed crawling over with lizards; and I thought to myself, that though gilded and golden, the serpent of vice is a serpent still.'

Melville's compatriot Edgar Allan Poe reacted with similar horror to night-time London. Poe's story 'The Man of the Crowd' opens with darkness falling over the city, bringing forth 'every species of infamy from its den'. The Man of the Crowd is an elderly passer-by whose strange expression strikes the narrator forcibly. His expression seems to convey 'the ideas of vast mental power, of caution, of penuriousness, of avarice, of coolness, of malice, of bloodthirstiness, of triumph, of merriment, of excessive terror, of intense – of supreme despair'.

The narrator follows the Man of the Crowd through London all night and until darkness falls again the following evening. Eventually he concludes that something mysterious is compelling the man to avoid solitude and immerse himself in the crowd. '"This old man", I said at length, "is the type and genius of deep crime."' As such he personifies Poe's idea that London threatened to destroy human values, and that its seething crowds might be the instruments of its own destruction.

Gerald Kersh knew London's seedy night-life from the inside during his varied career as a nightclub bouncer, cinema manager, wrestler and cook. His novel *Night and the City* (1938) centres on the ponce Harry Fabian, who 'saw London as a kind of Inferno – a series of concentric areas with Piccadilly Circus as the ultimate centre'. The lowest of metropolitan lowlife was to be found at the drinking club in New Compton Street run by the egregious Bagrag:

Bagrag's Cellar is a dragnet through which the undercurrent of night-life continually filters. It is choked with low organisms, pallid and distorted, unknown to the light of day, and not to be tolerated in healthy society. It is on the bottom of life; it is the penultimate resting-place of the inevitably damned. Its members comprehend addicts to all known crimes and vices. Mingling with them there circulate indefinable people, belonging to no place or category; creatures begotten of decay and twilight, enslaved by appetites so vile that even text-books never mention them, drifting in silent putrefaction to their unknown ends.

15

A typical slice of the Lee Valley (or Lea – the alternative spellings still survive after several centuries). The river's former flood plain accommodates a tangle of railway lines, canals, industry, trading estates, recreation grounds, parkland and power lines. The river flows south to meet the Thames at Canning Town.

Leeside Road, Edmonton

(following page)

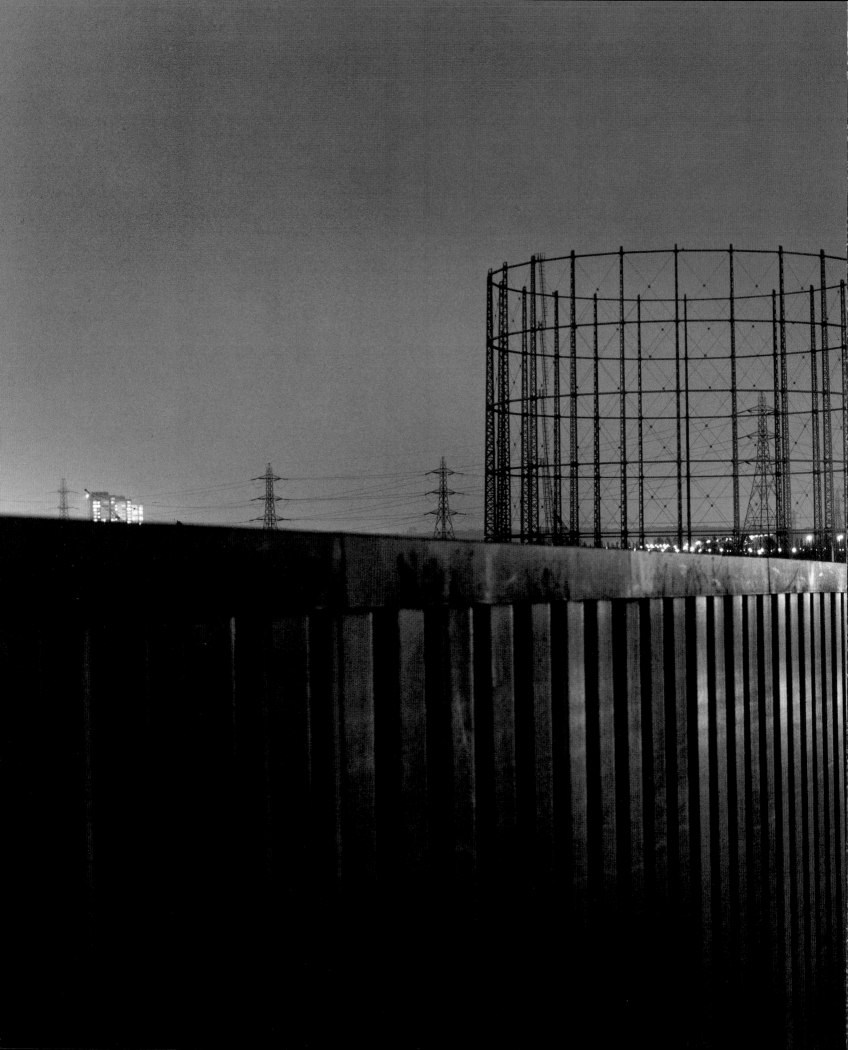

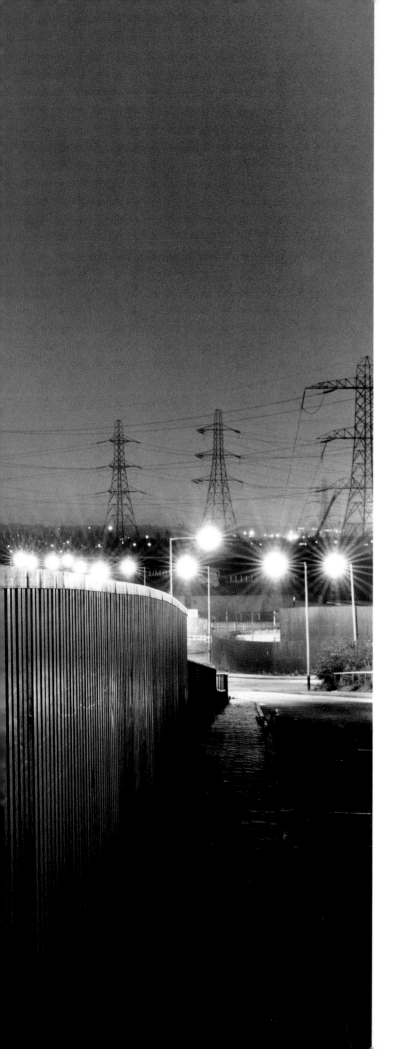

But Kersh did not hold the city to blame for the weakness of its inhabitants. *Night and the City* ends with one example at least of the human spirit triumphing over corruption, when the young manager of another sleazy night-club gives up his well-paid but demeaning job to become a sculptor.

Henry James was another writer whose affection for London survived the city's darker aspects. 'We are far from liking London well enough,' he wrote, 'till we like its defects: the dense darkness of much of its winter, the soot on the chimney pots and everywhere else, the early lamplight, the brown blur of the houses, the splashing of hansoms in Oxford Street or the Strand on December afternoons.' The metaphorically darker side, though, was a different matter. Hyacinth Robinson, hero of *The Princess Casamassima* (1886), notes 'the great ulcers and sores of London – the sick, eternal misery crying out of the darkness in vain, confronted with granaries and treasure houses and places of delight where shameless satiety kept guard'. Robinson asks himself, unhelpfully, 'What remedy but another deluge, what alchemy but annihilation?' James' own response to the city's misery was, while regretting it, to appreciate its contribution to 'the rumble of the tremendous human mill' which haunted, fascinated and inspired him.

What alchemy but annihilation? There has been no shortage of creative thought given to dreaming up answers for London over the years. Among the most influential visionaries was Ebenezer Howard, who at the turn of the century invented the concept of the garden city and claimed that the radical land-reform measures at the heart of his idea would cause land values in the old cities to tumble. The inevitable result, he said, would be an end to the evil of overcrowding and the gradual rebuilding of London at densities which would allow everyone a house and garden. It did not happen like that. London did lose population and jobs as the old city expanded into its hinterland, but only a small proportion of them went to garden cities and new towns, and metropolitan land values remained obstinately high.

After the Second World War Sir Patrick Abercrombie updated Howard's ideas. He based his plans for London on the strategy of strengthening existing communities and creating a new structure for the city and its region. Parts of Abercrombie's plans – green belt, new towns and arterial roads – were actually implemented. The same mood of post-war optimism was caught and shaped by the 1951 Festival of Britain on the South Bank of the Thames.

One of the festival's most memorable temporary structures was the Skylon, a functionless cigar-shaped construction which at night glowed from within and appeared to stand unsupported in the air. After the years of blackout, it seemed to symbolize the nation's deliverance from the powers of darkness. Londoners began to expect that their city would provide good living conditions for all. But the dream faded and the political will to implement radical development plans finally evaporated in the 1960s. By the 1980s, even as London boomed and its centre was extensively rebuilt, the media found the public receptive to stories of the capital's 'spiral of decline'. Its prosperity seemed to make its defects all the more apparent.

Londoners feel that their city is more dangerous at night than ever before. The police protest that the fear of assault, which inhibits so many from going out at night, is out of proportion to the risk. Their assurances are of little comfort to those who read the reports of innocent victims who wished they had stayed at home.

The night-time city is full of fear. Jonathan Raban wrote of London in *Soft City*: 'There are rumours of a gang called the Envies. Their brutal, seemingly motiveless assaults on strangers go largely unreported by the press, apparently for fear of "carbon copy" crimes. Who might not fall victim to the Envies? You have a car, a girl, a new suit, a cigarette, even a smile on your face, and they may come at you out of the dark.'

If the Envies did not exist, they had been invented by fear of the unknown. Every generation has to come to terms with the unknown city and to ask: what sort of creature is London? Henry James, for one, had no answer, and he tried to justify the lack of attention in most of his writing to all but a narrow range of the city's life. 'One has not the alternative of speaking of London as a whole, for the simple reason that there is no such thing as the whole of it ... Rather it is a collection of many wholes.'

When James wrote that in 1893, the Georgian-built city of Dickens' boyhood had been swamped. The population had exploded from less than two million to almost six in 70 years. Today the area that is effectively London is still spreading outwards, having long since leapfrogged the green belt that was meant to confine it. City, metropolis, megalopolis, metropolitan region: does it matter what we call it? Ford Madox Ford advised in 1935: 'London will always be, as she always was, "just London" ... a vast thing, ending one does not know where, beginning haphazardly and haltingly at no known point in the soiled green of

Beneath
Waterloo Bridge

Waterloo Bridge crosses the Thames in five handsome spans: not arches, but cantilevered concrete box girders. Its engineers designed it in collaboration with the architect Sir Giles Gilbert Scott. Begun in 1937, it was completed in 1942 by a wartime workforce of women. Across the river lies the Royal Festival Hall, and beyond it the Shell Centre – seven and a half acres of monotonous stripped classicism designed in the late 1950s, and a great lump of a tower – where a few oil executives are working late.

18

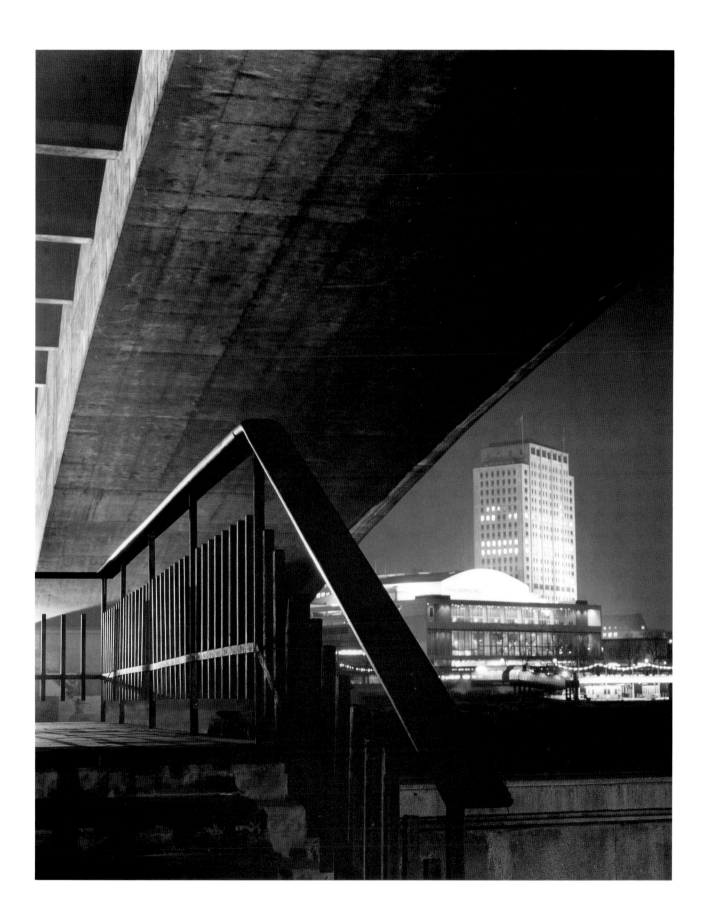

unknown fields ... a Gargantuan ragbag of a place; the eternal charlady in a mackintosh of the great cities past and to be.'

That is not good enough. London is a series of accidents of history, as most great cities are, but it cannot afford to wait for whatever accidents the future might bring. Today it is marketed as a 'world city', for fear that it might slip from the first rank. Finding the right phrase to describe it is a problem. 'The City', of course, refers only to the City of London, the financial district which in medieval times *was* the city but now has scarcely 5000 residents and is dead at night. It and the neighbouring City of Westminster have taken to referring to themselves as 'the twin cities', confusing the outside world still further.

London needs to be redefined, not only so that it can plan for its future, but so that its people can develop a civic sense of belonging to something more than a 'Gargantuan ragbag'. The confused face it presents to the world is bad enough: worse is the demoralizing lack of identity its own people feel with it. 'London as a single personality does not exist,' insisted Ian Nairn in *Nairn's London* (1966):

> It never has, at least from the moment when Edward the Confessor built his abbey on the marshes a couple of miles away from the original, homogeneous commercial city. All the attributes have piled on to this shallow basin of gravel like rugby players in a scrum, kicking and elbowing each other out of the way ... London is indeed a thousand villages; remove them and all that is left is a vast hulk peppered with spectacular buildings, quaint occasions, false sophistications and too many people on the Underground.

London as a city of villages is a familiar but misleading notion. Many of the villages which were overrun by the exploding metropolis do retain something of their identity, and the more affluent of their green-wellingtoned residents sometimes succeed in their attempts to ape Ambridge. But these places are the exception. Vast swathes of London are nothing more than suburban, often depressingly featureless and bleak. These suburbs have little identity of their own, nor do they share in the identity of the city itself.

Everyone knows what village life is meant to be like. But what should a city be like at the end of the twentieth century? The poet Ezra Pound, commenting on T.S. Eliot's vision of urban disintegration in *The Waste Land*, gave a clue. 'The life of the

Tower Bridge The announcement that a river crossing was to be built next to the Tower of London with at least 135 feet of headroom started a flurry of designing among Victorian engineers. An underwater arcade, a travelling deck on stilts and underwater rails, and a Paddle Wheel Ferry Bridge were all rejected in favour of the bridge, designed by Sir Horace Jones, that has become one of London's best-known landmarks since it opened in 1894. The raising of the centre bascules to let ships through is still an impressive sight, though rare these days. The top span used to provide a pedestrian footbridge, served by two lifts in each tower. The charmless Gothic stonework which was intended to complement the Tower of London clothes a steel skeleton. The composition is effective as a theatrical gateway to the capital of an empire, and the bridge looks best at night when that fantasy is aided by floodlights.

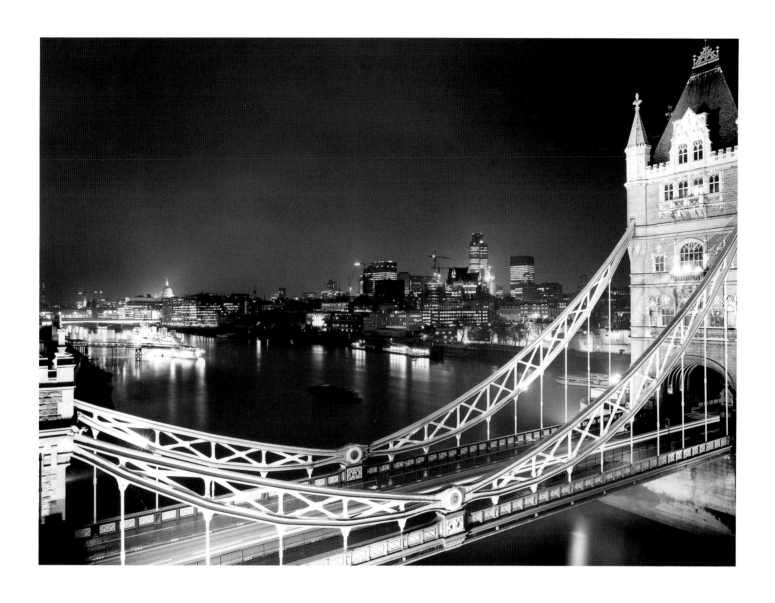

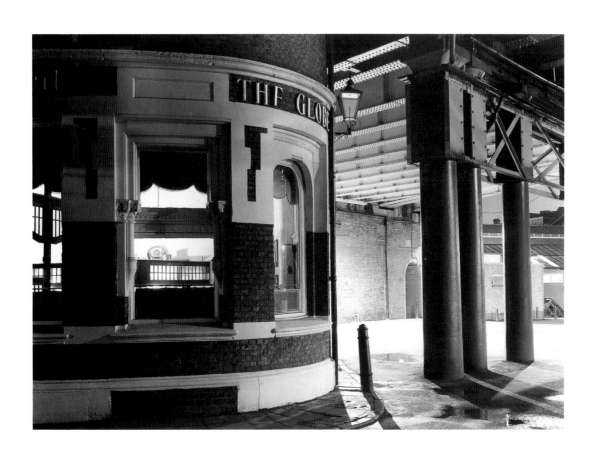

At night was come in-to that hostelrye
Wel nyne and twenty in a companye,
Of sondry folk, by aventure y-falle
In felawshipe, and pilgrims were they alle,
That toward Canterbury Wolden ryde

Chaucer was referring to the Tabard, the site of which is a few hundred yards from here. The Globe is named after Shakespeare's theatre, which was also nearby and is currently being built in replica.

Siting a theatre outside the boundaries of the City of London avoided the censor. The Globe (then called The Theatre) was at Shoreditch until 1597. A dispute then broke out with the landowner, who claimed that he owned not just the site but the theatre itself. James Burbage, who had built it, resolved the matter by having the timber building dismantled and re-erected in Southwark while the landlord was away for Christmas.

The Globe burned down in 1613 as a result of over-enthusiastic battleground effects in *Henry VIII*, without loss of life. 'Only one man had his breeches set on fire,' an eyewitness recorded, 'that would perhaps have broiled him, if he had not by the benefit of a provident wit put it out with Bottle-Ale.'

The Globe, Bedale Street, Southwark

village is narrative,' he wrote. '... In a city the visual impressions succeed each other, overlap, overcross, they are cinematographic.' If we expect London to be like a village but bigger, we are bound to be oppressed by the inevitable inconveniences of living in a city that grew 'with frightful, alarming, supernatural rapidity' (in the words of a contemporary commentator) in the nineteenth century. London is a mess. But it is a wonderful mess and it might yet have a future as a great city.

Historic London was a city of trade. It was the seat of government, the centre of an empire and the home of monarchs, but those functions were kept in their place. The merchants whose wealth built London were unwilling to allow it to be shaped according to the whims of others. After the Great Fire, Charles II and Sir Christopher Wren were sent packing with their plans for a city rebuilt with noble avenues and piazzas; the merchants wanted to start trading again as soon as possible, and new buildings laid out on the irregular, medieval street pattern suited them well enough.

Where London did achieve the little grandeur we admire today, it was generally as a by-product of commercial development in the periodic building booms. Land ownership by great estates, rather than small freeholders, provided the opportunity for new developments to be carefully planned, with strict leases as the means of control. The characteristic London square was found to be an ideal way of creating congenial private enclaves where people would want to live.

The restrained architecture of London's best Georgian streets and squares might be explained partly by the fact that so many of these town houses were merely adjuncts to the owners' country seats; and people who could afford to express their status in brick and stone tended to do it in the country rather than in town. But that does not account for the refined quality of more humble streets. The Danish writer Steen Eiler Rasmussen noted in *London: the Unique City* (1934):

While the Continental architect considered it his task to make the fronts of the buildings as imaginative as possible, the English endeavoured to let them express what had to be said in the simplest and most concise way.

The English house from this period is in accordance with the principles of Industrialism which in England was developing

already in the eighteenth century. Each building is not an individual work of art, but a refined industrial product brought to perfection through constant selection during repeated serial construction.

That combination of planning, building regulations and market forces produced the Georgian streets and squares whose remnants make us wonder why we so rarely create such well-mannered cityscapes today. In the 1970s it became apparent that progress in urban improvement had ground to a halt. That was a shock to a generation used to the idea that rational beings were capable of getting cities under control. By the 1980s, the government preached a new gospel: that the market had the divine right to shape cities, and that we should sit back and enjoy the experience.

Ministers explained that London's public transport was painfully overstrained, not because of bad planning, but as an inevitable result of the attractiveness of the city's booming economy. Likewise, they said, the increase in homelessness and begging was natural in a city whose streets seemed from afar to be paved with gold. The time to worry, Londoners were told, would be if the tube trains ever rattled around half empty and if the young fortune-hunters from Glasgow, Newcastle and Liverpool decided they would be better off staying at home.

That episode is history. Nowadays it is generally recognized that the market, made up of countless individuals making economic decisions, is incapable of shaping London coherently. The developers – the market's most visible personification – admit it as readily as anyone. Now no one has any faith in anyone else's ability to get to grips with London.

The demise of the Greater London Council has meant that London's strategic planning is now done by the London Planning Advisory Committee working from the absurdity from of Romford, Essex, its planners spending much of their time on the train to central London, shuttling back and forth between meetings.

London is often contrasted with Paris. The French capital has leadership and a vision of what it is trying to become; London does not. But Paris's traditions are absolutist, London's are democratic. For all Paris's architectural *grands projets* and sense of direction, the lot of the average Parisian is much the same as that of the average Londoner. London does not need a new vision of itself as a great centre served by anonymous suburbs: it outgrew that structure long ago and is now too centralized for its own good. The new London must be a federation of real places: a many-centred

Annett's Crescent, Essex Road, running north from Islington Green towards Newington Green,
Essex Road, Islington was a coaching road when this crescent was built alongside it in 1819-20.

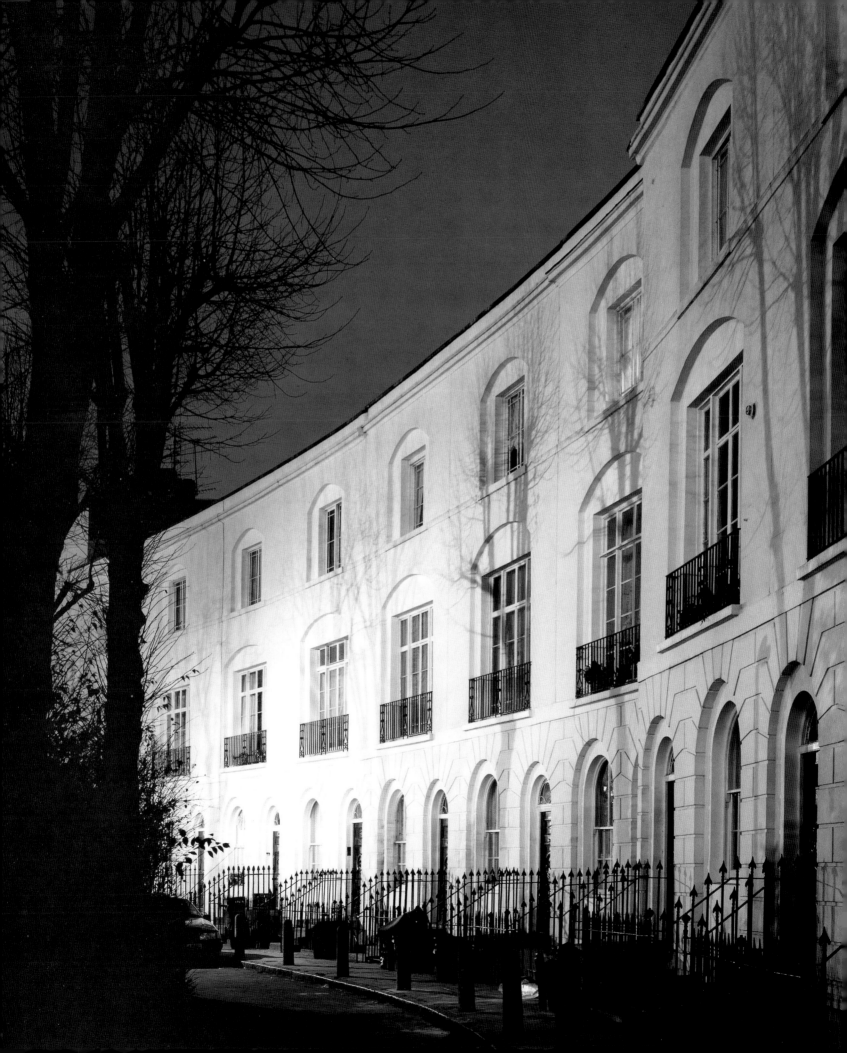

city region based on developed communities, each with its own distinct identity.

The structure of London is dramatically changed from the days when the new suburbanites walked to their work in the City. Today the metropolis is defined by networks of travel, communications and influence rather than by conventional boundaries. Its future will depend on the life of those networks and on how effectively Londoners communicate within and between a hundred different categories – ethnic, cultural, economic, religious, professional and geographical. London is fortunate that its amazingly diverse social and ethnic groups coexist in a degree of peace, a striking contrast to the many parts of the world where anyone different is seen as a threat. Such diversity will become a source of strength or a cause of conflict, depending on whether its existence is welcomed or suppressed.

Cities these days compete internationally for status and even survival. Few pay as little attention to identifying and making the most of their strengths as London. If it is to flourish economically in the coming decades, London is likely to do so in large part through marketing its intellectual and cultural capacities to a world hungry for communication, education and training, research, entertainment and the arts. How much it has to offer will depend on whether its own communities have succeeded in transforming themselves into fertile ground for such fruits of civilization.

Saving London from a dark future will be a messy but exciting process, for which we can invoke the closing lines of Kersh's *Night and the City* as a metaphor:

Goodwood Court, Devonshire Street

The elegant Art Deco door belongs to an otherwise undistinguished block of flats in Devonshire Street. Many of central London's streets and squares take their names from places associated with the ground landlord. In the case of Devonshire Street, the landlord was the Duke of Portland (hence Portland Place, which it crosses); the Duke of Devonshire was a relative.

> Outside, the dull moon – little, fickle satellite – trails after the advancing earth, like a prostitute at the heels of a battered soldier, marching on in blind obedience to incomprehensible orders, across the desert of the skies.
>
> The night bursts open. Blood and life soak into the sky. Torn at the edge by the black silhouettes of spiky spires, and cold chimneys – polluted but bright, ragged but triumphant – dawn breaks over the city.

Londoners have never been wholly persuaded that cities are anything but a necessary evil, and daily experience of their own city often takes them to the brink of giving up hope for its future. Alan Delaney's photographs, representing one person's exploration, are offered in the hope that others will share the exhilaration of discovery.

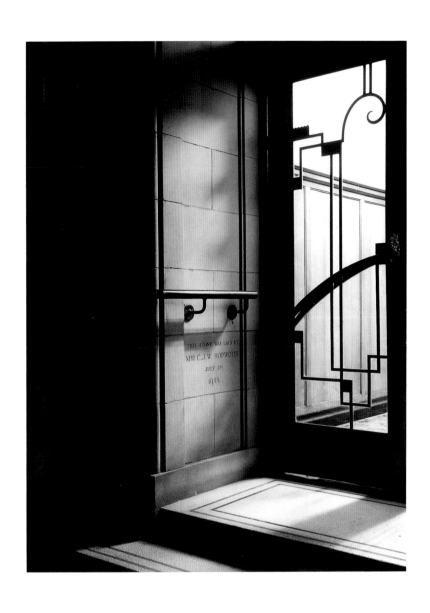

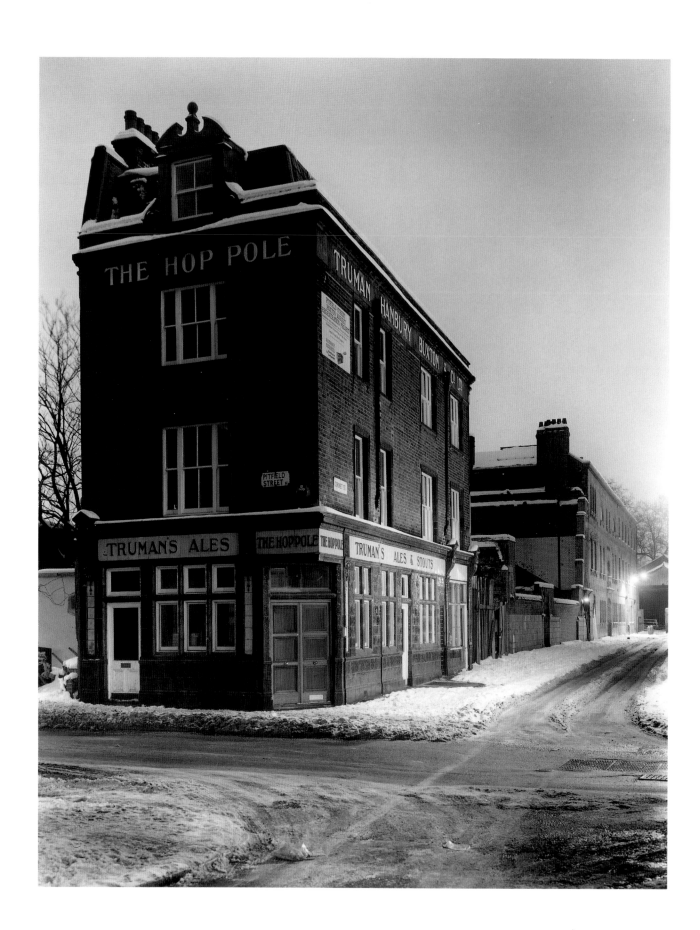

The Hop Pole,
Hoxton

The former pub is closed and awaits conversion to offices and workshops. Four hundred years ago Hoxton was a good place to drink. A pamphlet of 1598, 'Newes from Hogsdon', sang the praises of the brewer Ben Pimlico: 'Have at ye then, my merrie boyes, and hey for old Ben Pimlico's nut browne.' At that time Hoxton was still a pleasant village where wealthy Londoners came to live or enjoy themselves. By the nineteenth century Hoxton was a slum, and post-war redevelopment has not brought it prosperity. In boom times local residents alternate between complaining that the influence of the City's economy never seems to spread across Old Street, and suspecting that they would not be the ones to benefit if it did.

A Truman's pub such as the Hop Pole could be relied on to serve beer whose connection with hops went beyond the pub's name. With other establishments it was not always so. J. Ewing Ritchie wrote in *The Night Side of London* in 1869 of the evils which went on in London after dark. These included watering the beer and, to prevent customers noticing, adding a few other ingredients: 'liquorice, to sweeten it; a bitter principle, as gentian and quassia; sumach and terra japonica, to give it astringency; linseed, to give it body; burnt sugar, to darken it; cocculus indicus, to give it false strength; and common salt, capsicum, copperas, and Dantzic spruce, to produce a head'. Would hops not have been cheaper than that exotic concoction of poisons?

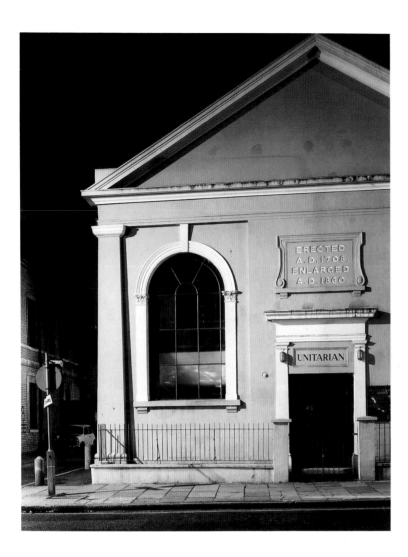

The Unitarians rejected the doctrine of the Trinity and were ejected from the Church of England in 1662 by the Act of Uniformity. Newington Green, originally the green of a hamlet north of London, became a centre for them and other Nonconformists. Here numerous dissenting clergymen lived, preached and set up schools and academies. The writer Daniel Defoe was among their pupils, as was the preacher and hymn-writer Charles Wesley. Mary Wollstonecraft, educationalist and campaigner for women's rights, ran a school at Newington Green in the 1780s.

Unitarian chapel,

Newington Green

Portland Place
Lord Foley thought that the conditions of his lease guaranteed that nothing
would be built to spoil his view of the open land north of Foley House.
When the Adam brothers looked into the matter they found that they were
only prohibited from building on a strip as wide as the house itself. His
lordship was dismayed when in 1778 the brothers laid out Portland Place
to the exact width of Foley House, and started building on either side: he
now lived at the end of a cul-de-sac. The street's grandeur led John Nash
to incorporate it as the northern end of his Royal route from Carlton House
to Regent's Park. Most of the Adams' buildings have gone, but Portland
Place still offers a dignified location for embassies and professional
institutes. The site of Foley House is now occupied by the Langham,
which was built as a hotel in 1864 and has recently become one again.

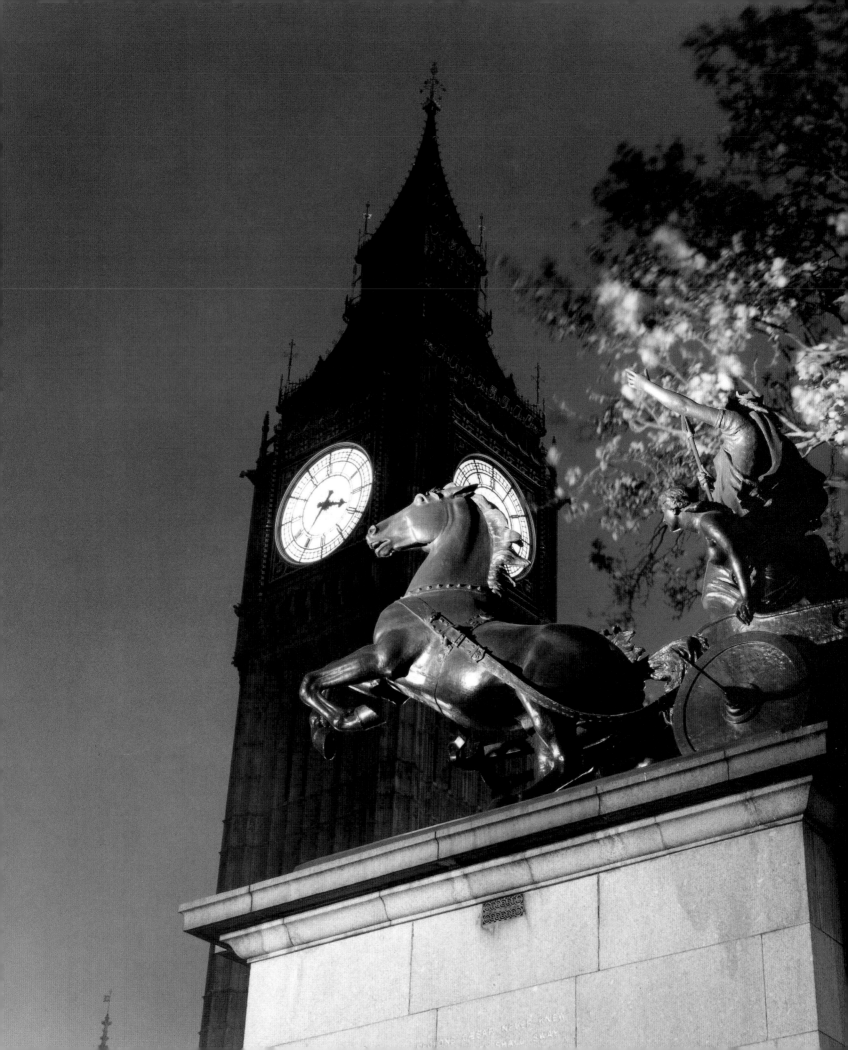

Statue of Boadicea,
Westminster Bridge

Boadicea, Queen of the Iceni, sacked London in AD 61: 'slaughter, gibbets, flame, torture' was Tacitus' terse report of the consequences. Londoners seem to have forgiven her, presumably because of her heroic leadership of the indigenous people against the Romans. Thomas Thornycroft made the bronze statue of Boadicea and her daughters in the 1850s, but it was not unveiled until 1902.

Westminster Abbey was begun in 1245. Renovation work started in 1373 and has continued on and off ever since, so it is hardly surprising that not a single stone seen in this photograph is original thirteenth-century work. Serious renovation of the north transept began in 1662, at a time when to remove old-fashioned Gothic details was thought to be doing the building a favour. In 1719, with the Gothic style in fashion again, the original design was reinstated, but with amendments where the thirteenth-century masons were thought to have been insufficiently imaginative. During his 30 years as Surveyor to the Abbey between 1849 and 1878, Sir George Gilbert Scott, and later his son John Oldrid Scott, restored the lower part of the north transept front to its original appearance as far as they could, on the basis of careful study and some imaginative guesswork. John Loughborough Pearson took over as Surveyor in 1878. By 1892 Pearson had rebuilt the upper parts of the north transept front, and with supreme insensitivity had replaced some thirteenth-century work with very different details of his own. The fiction was now complete. One day this too will crumble, and a new generation will have to decide what is the right way to restore medieval architecture that dates from the late nineteenth century.

Westminster Abbey, north transept

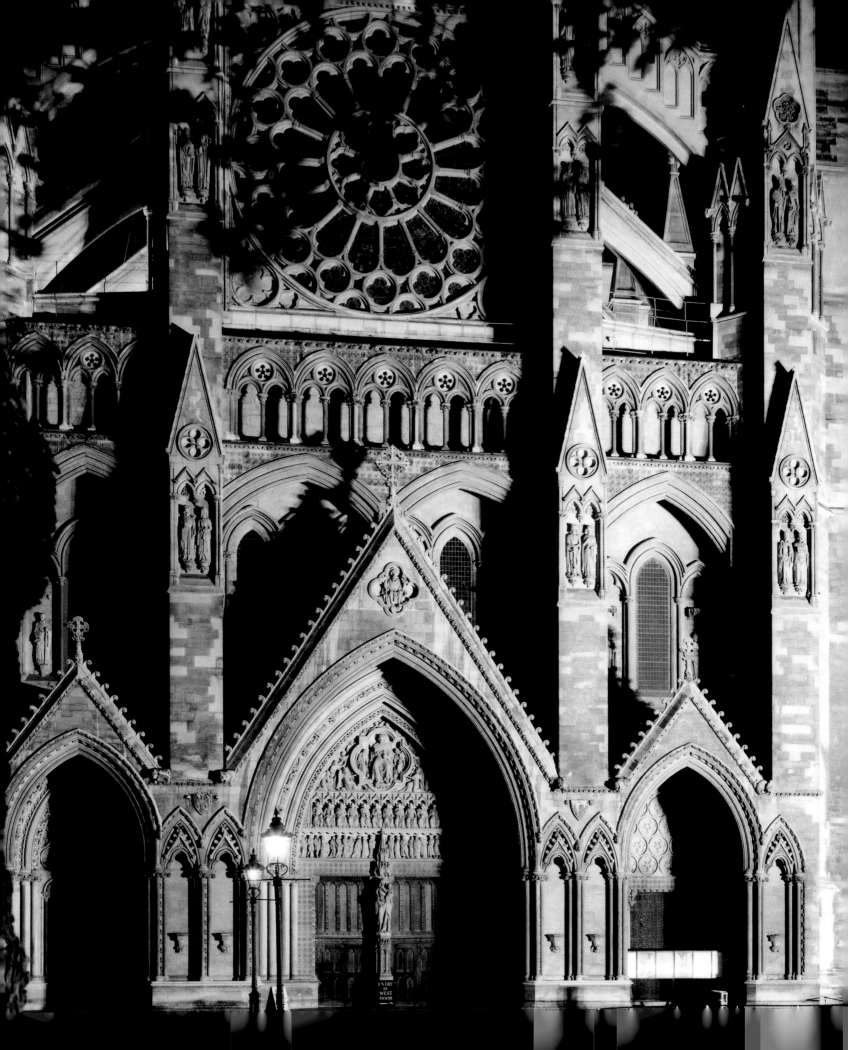

Dolphins twist around the post that holds an orb of light: this is how the city at night was charmingly celebrated in 1870. The Albert Embankment was built by the Metropolitan Board of Works in 1866-70 with two functions: to accommodate the huge brick sewer built to intercept the old sewers which flowed through south London into the river, and to prevent flooding.

'The most effeminate and effectless heap of stones ever raised by man' was John Ruskin's assessment of the Palace of Westminster in 1854, when it was still being built. Today we can appreciate the palace – home to the Houses of Parliament – as a brilliantly original solution to the problem of creating an enormous building which is neither monotonously repetitive nor overbearing. It was the fruit of a partnership between two very different architects: Charles Barry, who won the design competition in 1835, and A.W.N. Pugin, who was responsible for the Perpendicular Gothic detail. Pugin, a fanatical advocate of Gothic architecture, once jokingly dismissed the palace as 'All Grecian, Sir; Tudor details on a classic body' – but in the hands of these two masters it was a combination that worked.

**The Palace of Westminster
from the Albert Embankment**

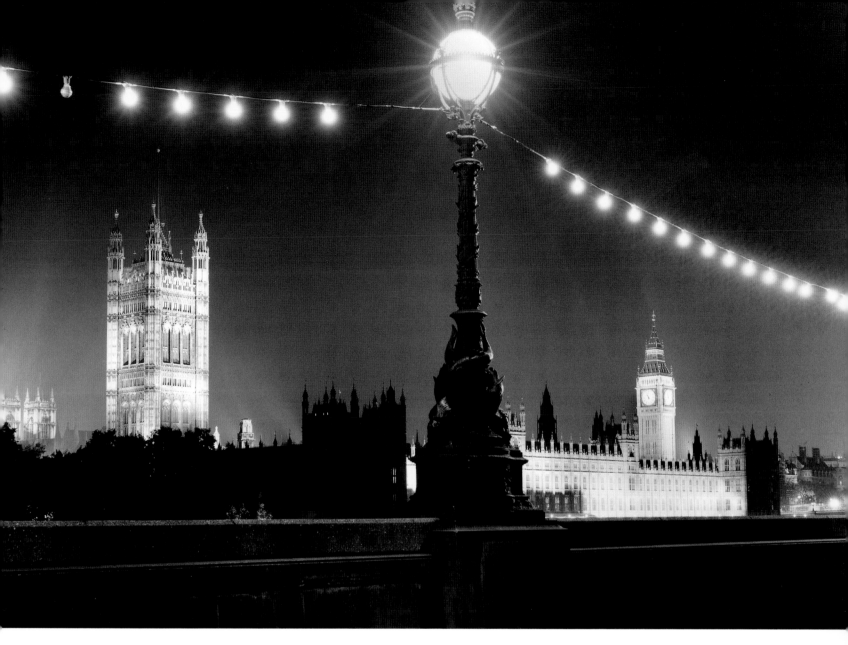

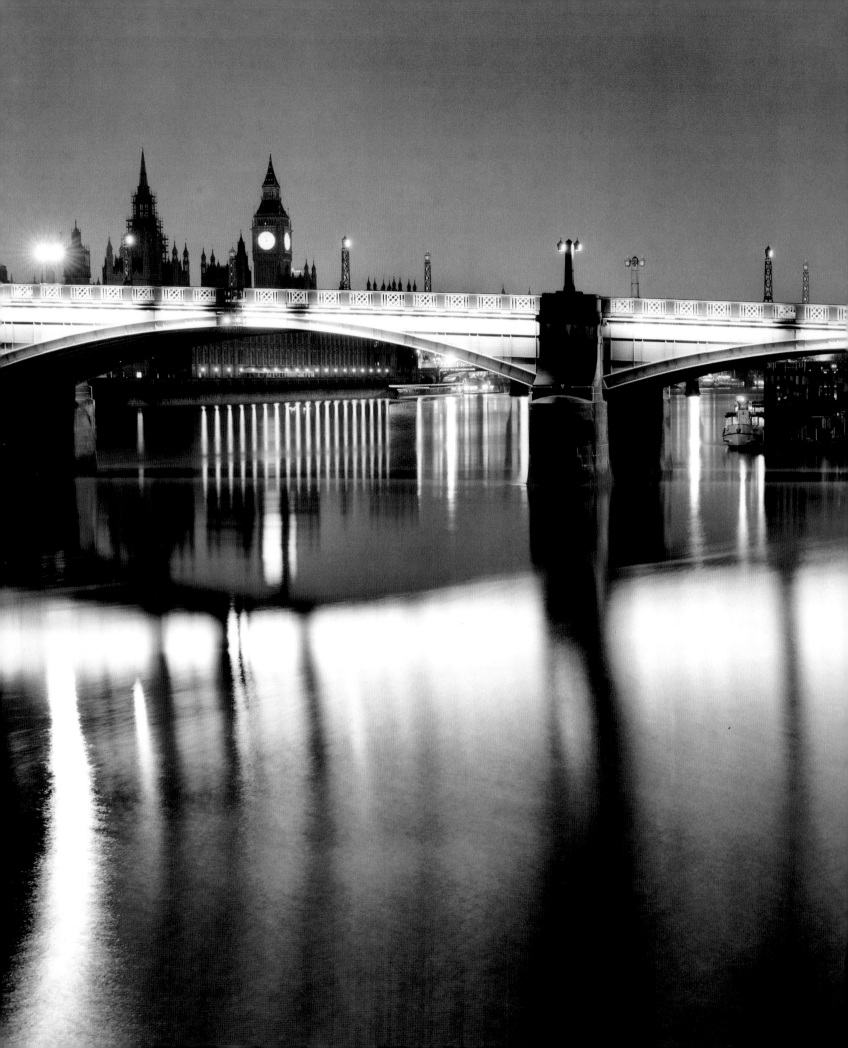

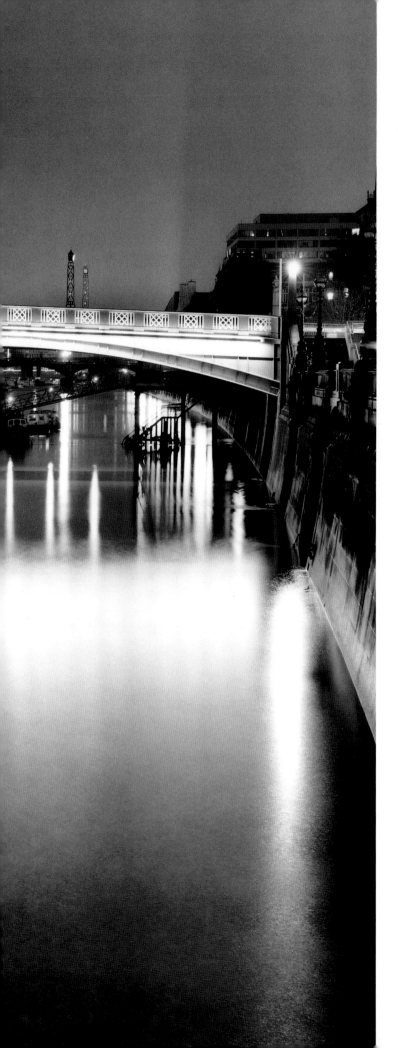

Lambeth Bridge

There used to be a ferry here: Archbishop Laud used it in 1633 when he was moving in to Lambeth Palace, and so overloaded the boat with his belongings that it sank. No doubt his calling helped him to draw the appropriate moral. Work on the present Lambeth Bridge, the second on the site, began in 1929. In the same year Richard Aldington wrote of a walk on the Embankment by two characters in *Death of a Hero*. 'A few trams and taxis were still moving on the Embankment, but after the ceaseless roar of day traffic the air seemed almost silent. At times they could hear the lap and gurgle of the swift river water, as the strong flood tide ran inland, bearing a faint flavour of salt. The river was beautifully silver in the soft, steady moonlight which wavered into multitudes of ripples as soon as it touched the broken surface of the Thames. Blocks of moored barges stood black and immovable in the silver flood ... Midnight boomed with majestic, policeman-like slowness from Big Ben; and as the last deep vibrations faded from the air, the great city seemed to be gliding into sleep and silence.'

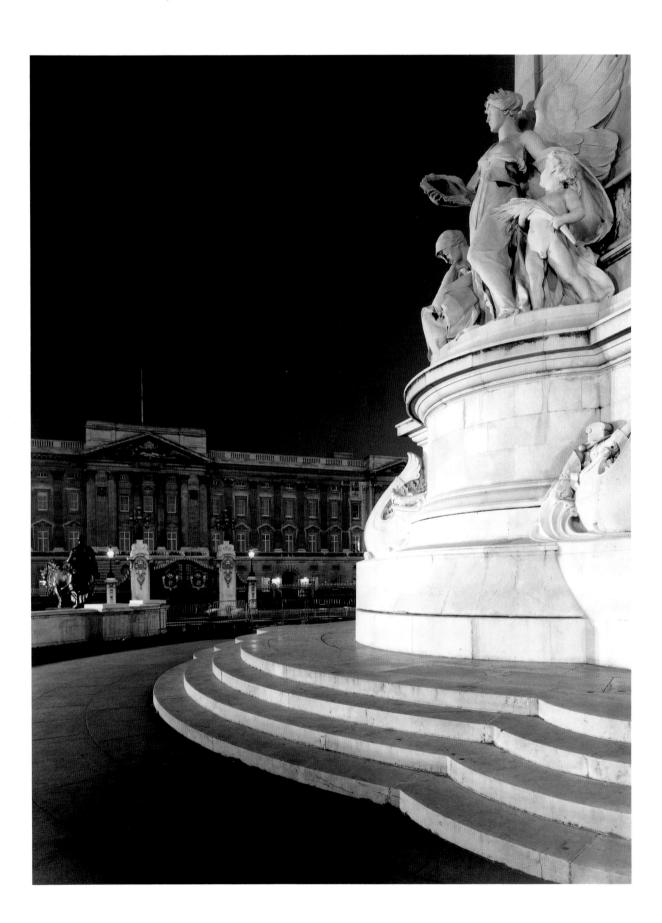

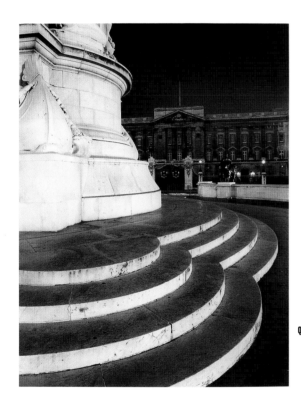

Queen Victoria Memorial and Buckingham Palace

With the guards changed and tucked up in bed, the marble figure of Justice keeps an eye on the royal household. The building of Buckingham Palace was a long, sad tale. The Prince of Wales, later George IV, had spent 30 years and vast expense on turning Carlton House into a palace; but when he became king he decided to demolish it and build something grander on a different site. John Nash was the first architect to be given the job of creating a palace for him, from a house which had originally been built for the Duke of Buckingham. By 1830 Nash had managed to put together an extravagantly wasteful patchwork of a building. Several other architects followed, each under instructions to bring the project to some sort of conclusion. The last of them was Sir Aston Webb, who in 1913 hid the east front behind a new Portland stone facade. That is what today's visitors, peering through the railings at the Changing of the Guard, see as Buckingham Palace. Webb's facade was part of an exercise in regal stage-setting which also included the roundabout in front of the palace, with its Queen Victoria Memorial. This was designed by Webb, with statuary by Sir Thomas Brock, and incorporated 2300 tons of marble, gilt and bronze.

The predecessor to St Paul's, Old St Paul's, had been neglected and vandalized in the years since the English Reformation (despite John Revell's attempt to inspire Queen Elizabeth by presenting her with a marzipan model of his proposed restoration on New Year's Day, 1562). Sir Christopher Wren presented his own commissioned plan for renovating the old cathedral – featuring a dome topped by a 68ft-high stone pineapple – only six days before the outbreak of the Great Fire in 1666. Wren had always advocated demolishing and rebuilding St Paul's; the fire gave him his opportunity.

St Paul's Cathedral

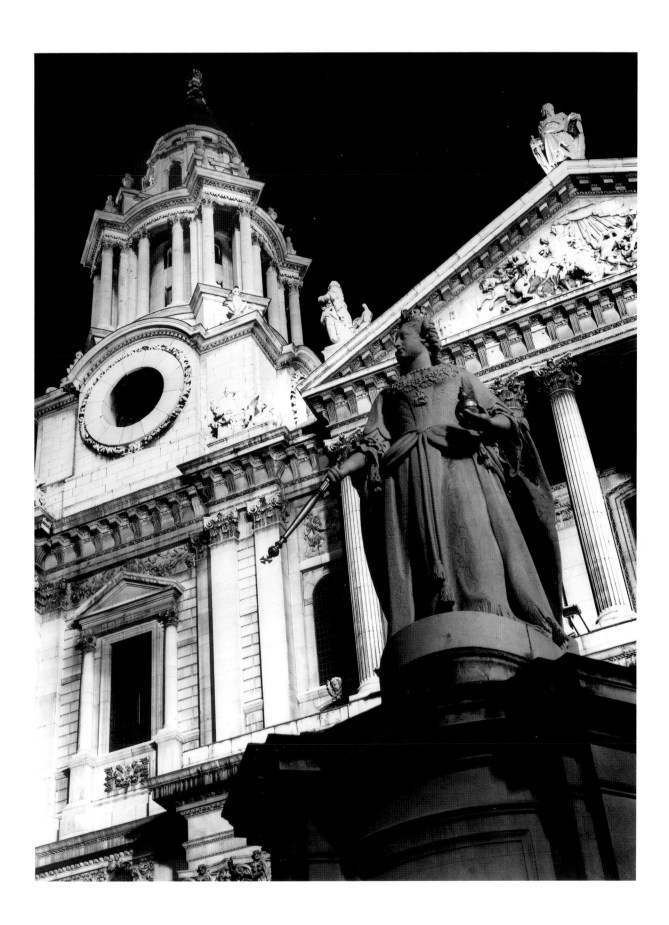

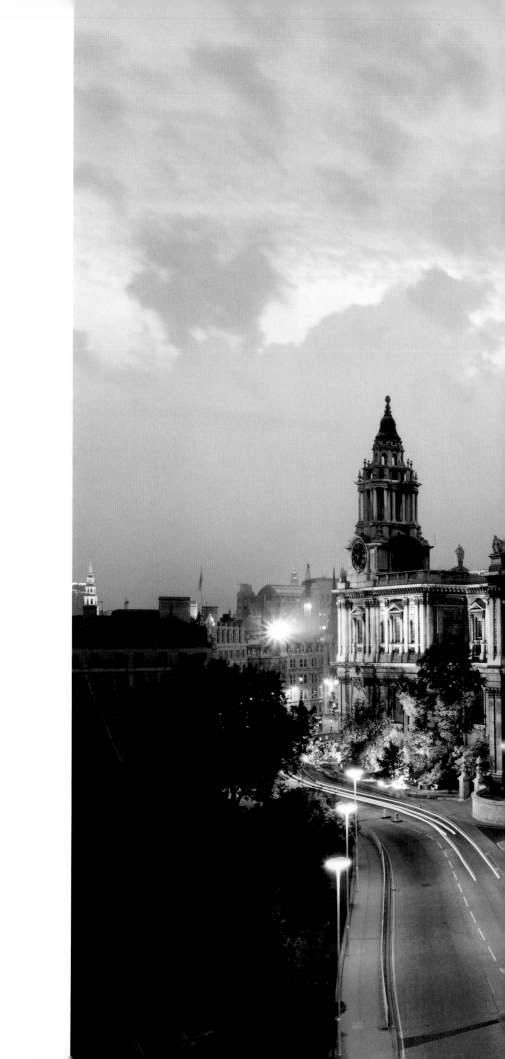

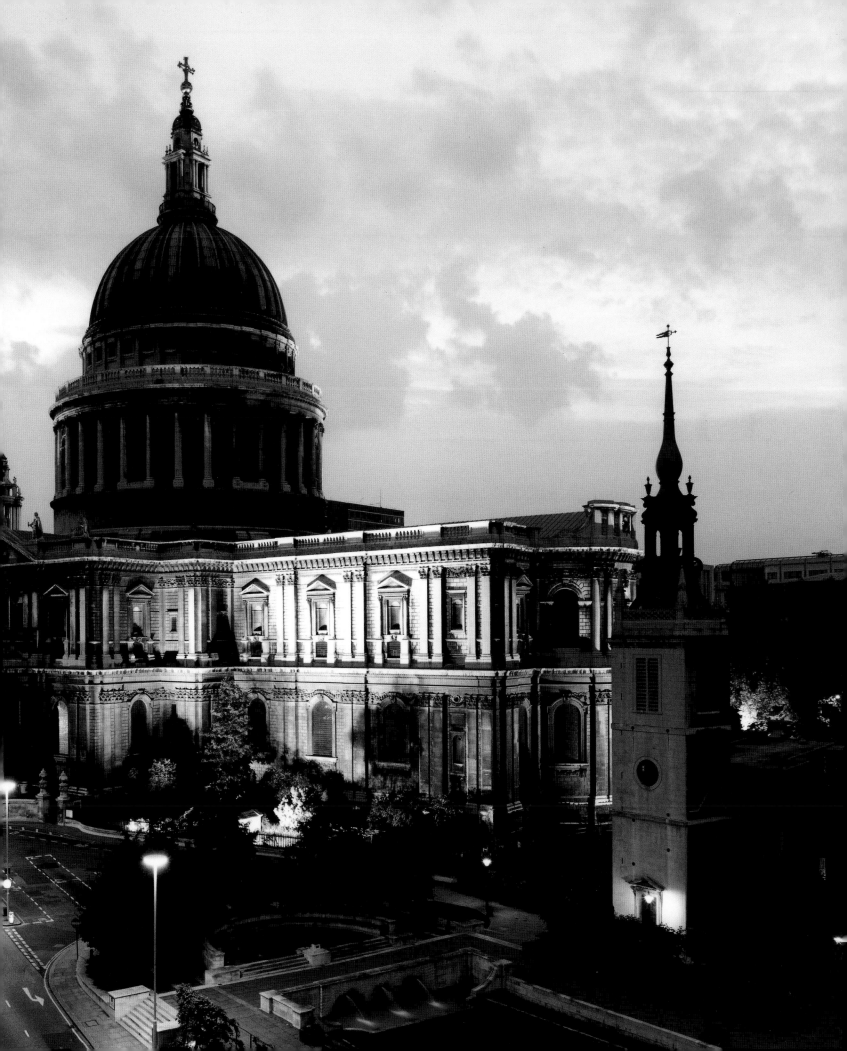

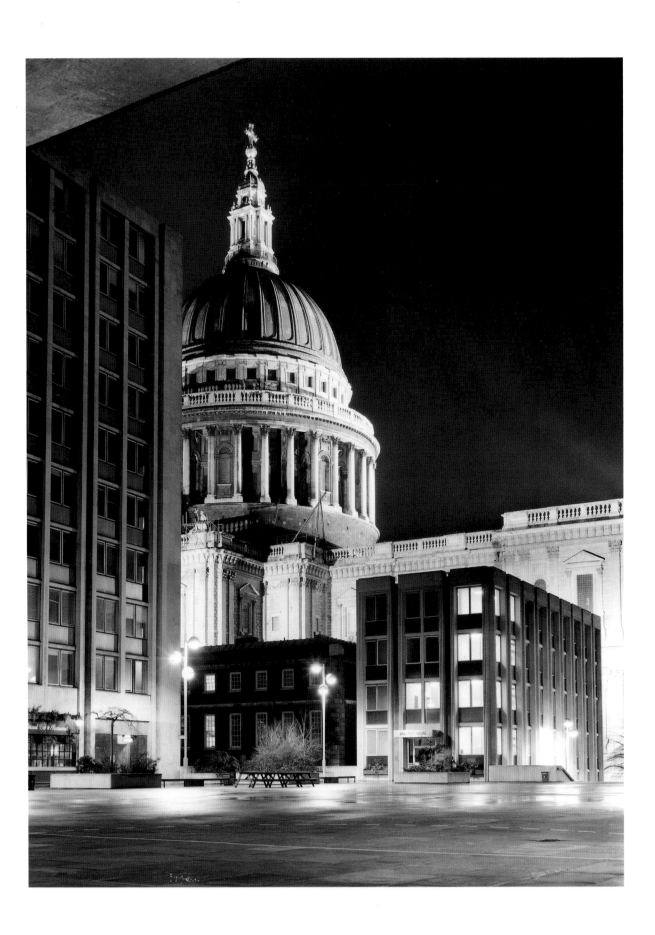

Paternoster Square and St Paul's Cathedral

Paternoster Row used to be the centre of London's bookselling and publishing trades. When the Great Fire broke out on 2 September 1666, the stocks of books were moved to the supposed safety of St Paul's Cathedral and sealed up in the crypt chapel of St Faith. In vain: the burning cathedral collapsed through the chapel's vaulted roof, and all was lost. The booksellers and publishers returned to Paternoster Row after the fire. The street and a further six million volumes were destroyed in a night of bombing by the Luftwaffe on 29 December 1940.

Paternoster Square, at the west end of Paternoster Row, was rebuilt in the 1960s as a pedestrian precinct, elevated over a carpark. The result is dull and spiritless. In the 1980s the scheme's unpopularity attracted the attentions of developers who saw a chance to build even more offices. Since then, no site in London has been the focus of such vociferous debate.

The urge to glorify God is a fine impulse for great architecture, but a secular motive often helps. In 1710 the Tories won a general election after 22 years of Whig power and decided to celebrate. Like politicians before and since they chose to display their power through buildings – in this case, as the Act of 1711 defined, 'fifty new churches ... in or near the Cities of London and Westminster or the Suburbs thereof'. That irrepressible partnership between God and the Tory Party would be glorified by 'churches of stone and other proper Materials with Towers or Steeples to each of them'.

The coal tax which was meant to pay for the churches did not stretch to as many as 50, but there are some masterpieces among the dozen that were built. One of them is Nicholas Hawksmoor's Christ Church, Spitalfields. The sombre glory of Hawksmoor's invention adds to the sense of dignity which Spitalfields has acquired through the dogged survival of some of its early Georgian streets in the face of age, neglect and developers. The fruit and vegetable market, neighbour to the church, closed in 1991.

Christ Church and the Market, Spitalfields

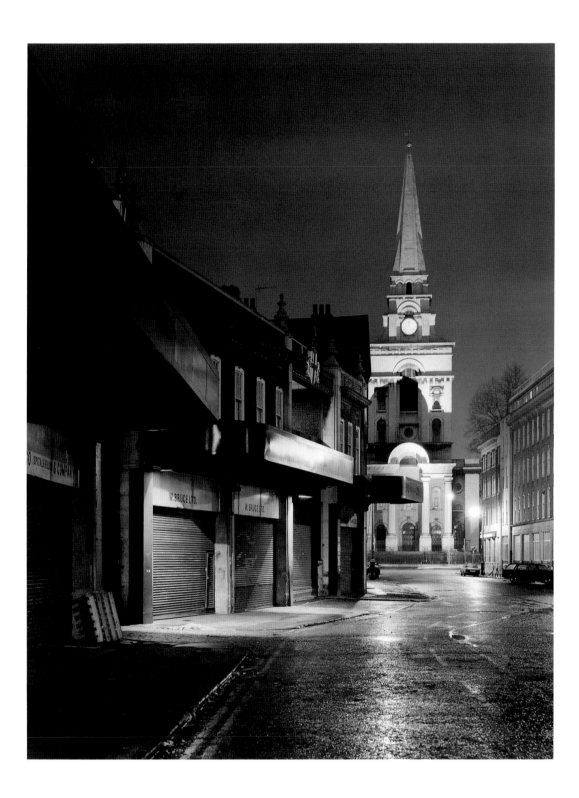

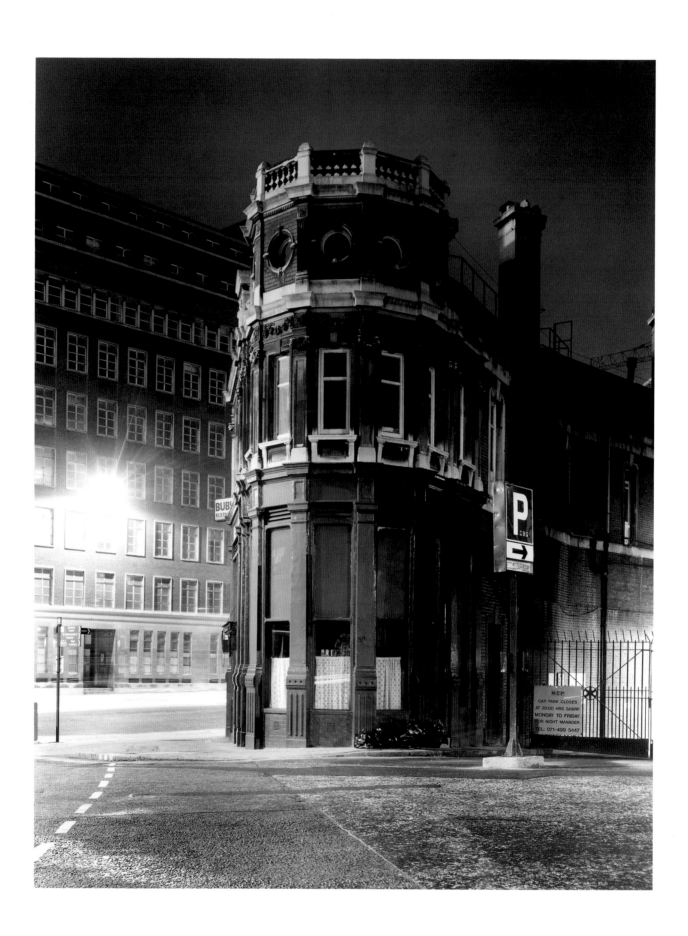

It is said that in the eighteenth century young men used to put elderly women in barrels and roll them down Snow Hill. The practice, happily, has long been discontinued.

Snow Hill, Smithfield

**Hanbury Street,
Spitalfields**

Seen across Commercial Street, Hanbury Street is dominated by Truman's Black Eagle Brewery. Joseph Truman founded it in the early eighteenth century, Sampson Hanbury took over in 1780, and a hundred years later the company was the world's largest brewer. The extensive complex of buildings is an exception in an area otherwise characterized – as it has been since the seventeenth century – by the small-scale trading and manufacturing of textiles.

Spitalfields has always been dominated by immigrants: Huguenot silk weavers on the run from persecution in France in the 1680s, Irish Catholics, Jews and, today, Bengalis (mainly from the Sylhet, a rural district of Bangladesh). Being just outside the eastern boundary of the City of London, the Huguenots could escape the restrictions of the guilds. Later immigrants came because the cheap housing was all they could afford: the area still has housing as squalid and overcrowded as anywhere in Britain.

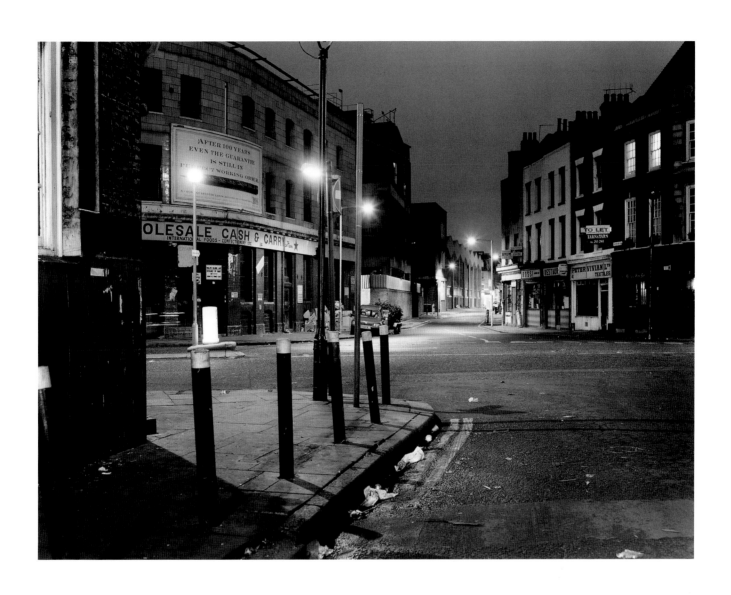

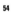

Ridley Road, Dalston

The area may be rundown and impoverished, but it is full of life by day and night. Taxi drivers, security guards, the police and the local Afro-Caribbean population returning from a night out at the clubs are among the clientele who take advantage of the fact that the Jewish bakery and delicatessen offers its superb salmon and cream cheese bagels 24 hours a day.

Smithfield Market

(opposite page)

'... and so into Smithfield ... It was market morning. The ground was covered, nearly ankle-deep with filth and mire; a thick steam perpetually arising from the reeking bodies of the cattle, and mingling with the fog ... the hideous and discordant din that resounded from every corner of the market; and the unwashed, squalid and dirty figures constantly running to and fro, and bursting in and out of the throng rendered it a stunning and bewildering scene.'

That, according to Dickens in 1838, was Oliver Twist's experience of London's ancient meat market. In 1855 those 'reeking bodies' were relocated to the Metropolitan Cattle Market in Islington, but their carcasses remained as welcome as ever at Smithfield.

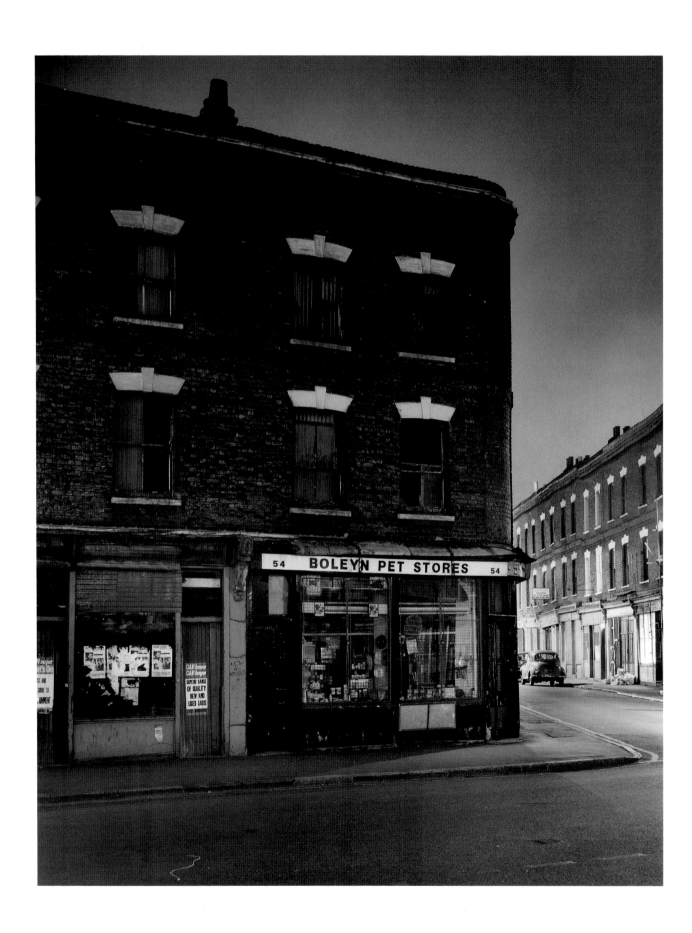

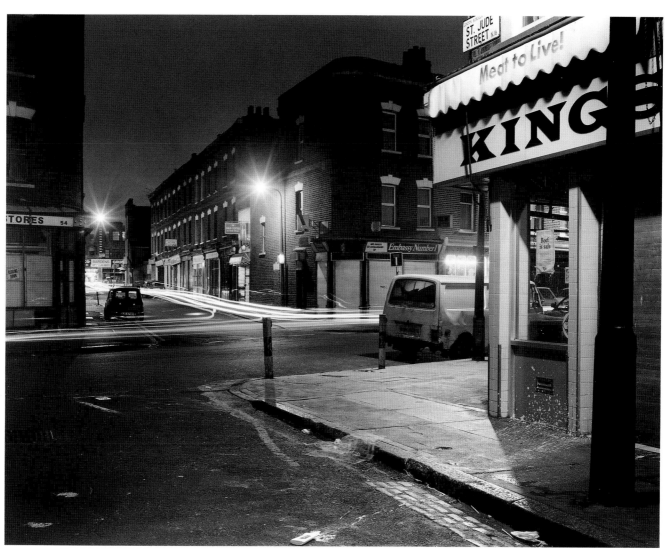

**St Jude Street
and Bradbury Street,
Dalston**

Across Boleyn Road from St Jude Street is Bradbury Street. This still has its original shop fronts and it sports a jaunty irregularity of window-sill lines, evidence that the street is sinking in more ways than one.

Boleyn Road, Dalston

(opposite page)

The road gets its name from Anne Boleyn. The flimsy excuse is that Boleyn Road leads to Newington Green, where there was a royal hunting lodge which Henry VIII visited, possibly with his second wife. The Boleyn Pet Stores has since gone the way of the shop next door.

Mr Bates and his son – 'Tin, Zinc & Copper Workers' as the sign on their Chequer Street frontage declared – are long departed, and since the photograph was taken their premises have been demolished and replaced by an office building. The front door of Bates and Son opened on to Bunhill Row and overlooked Bunhill Fields, which from 1666 was London's main cemetery for Nonconformists. Those who refused to accept the authority of the Church of England came to rest there, in the illustrious company of William Blake, Daniel Defoe and John Bunyan.

Bunhill Row,
Finsbury

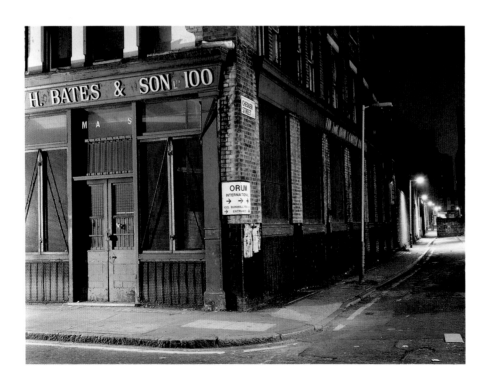

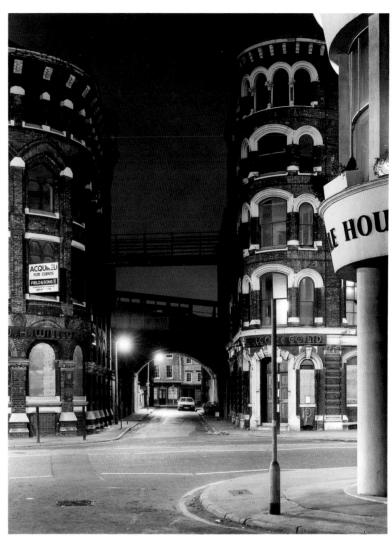

Southwark Street For 30 years after 1855 the Metropolitan Board of Works carried out

extensive engineering projects: sewers, embankments and roads.

Southwark Street was carved through the squalid slums between

Blackfriars and London Bridges in 1862, and was the first in London to

run water mains, gas pipes and telegraph cables in a duct down the middle

of the road. The street was soon lined with splendid palaces of commerce:

no. 49 (seen here on the left), built in 1867, was one of the earliest.

The name, if nothing else, recalls the romantic days of steam. The railway
connection is provided by Finsbury Park station, opposite the pub.

The Silver Bullet,

Finsbury Park

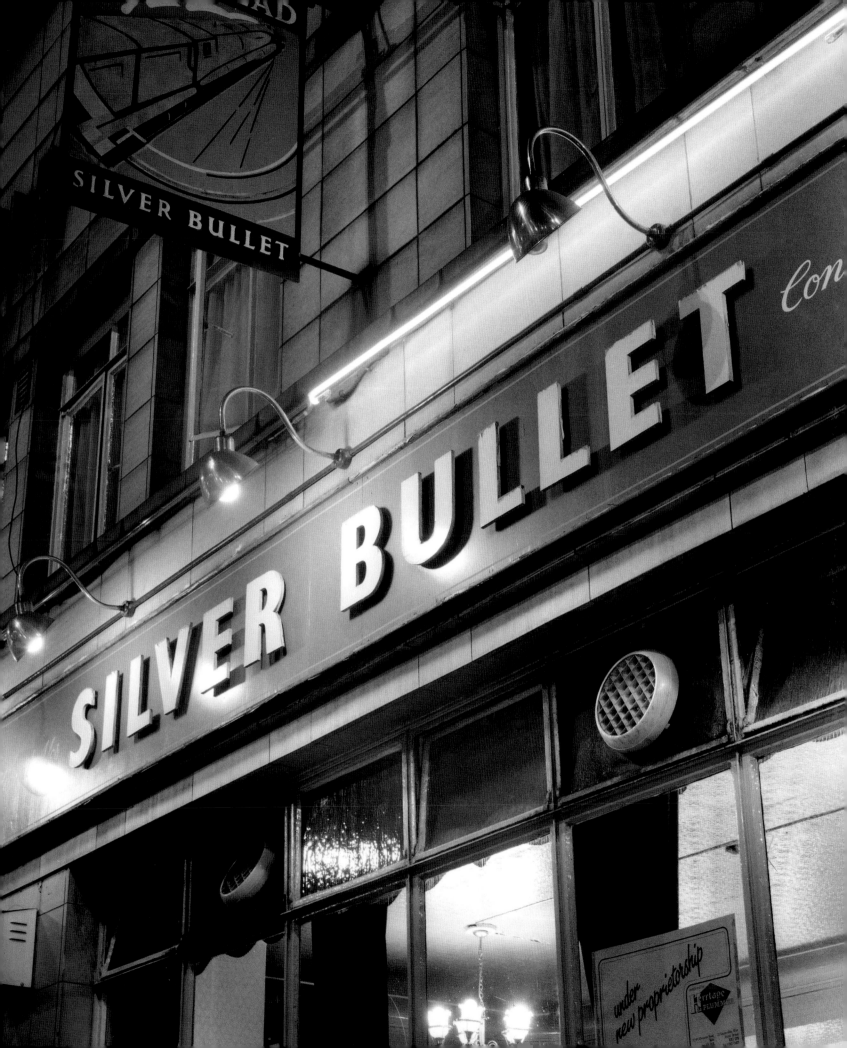

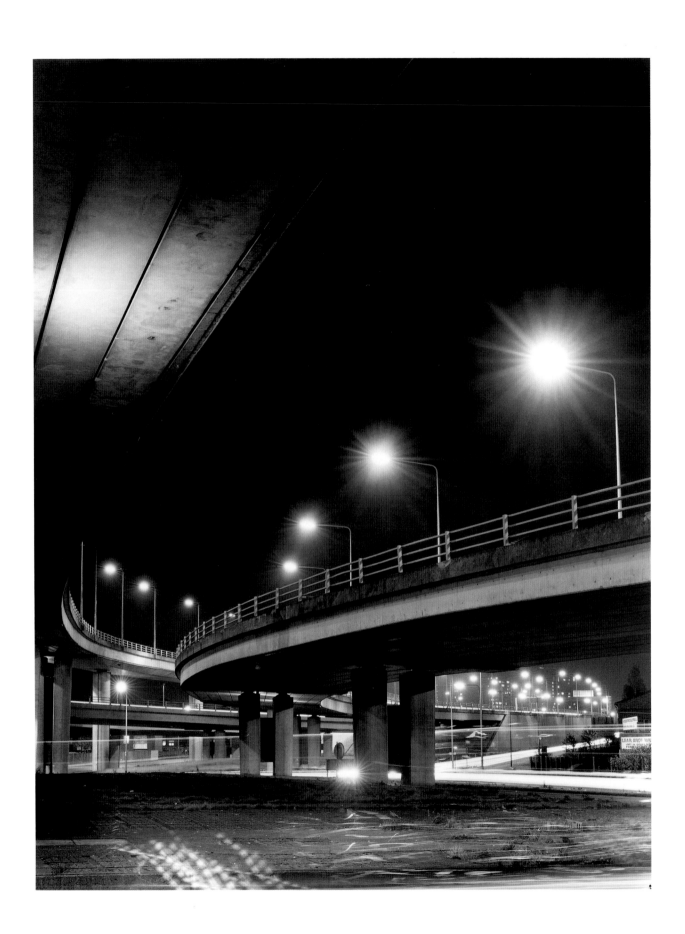

Under the M11
at Woodford Green

There's a river here. Like most of London's rivers, the Roding is well hidden – in this case under the M11, which meets the North Circular Road in a tangle of asphalt and concrete spaghetti. But the photographer was surprised to see a heron fishing here at midnight.

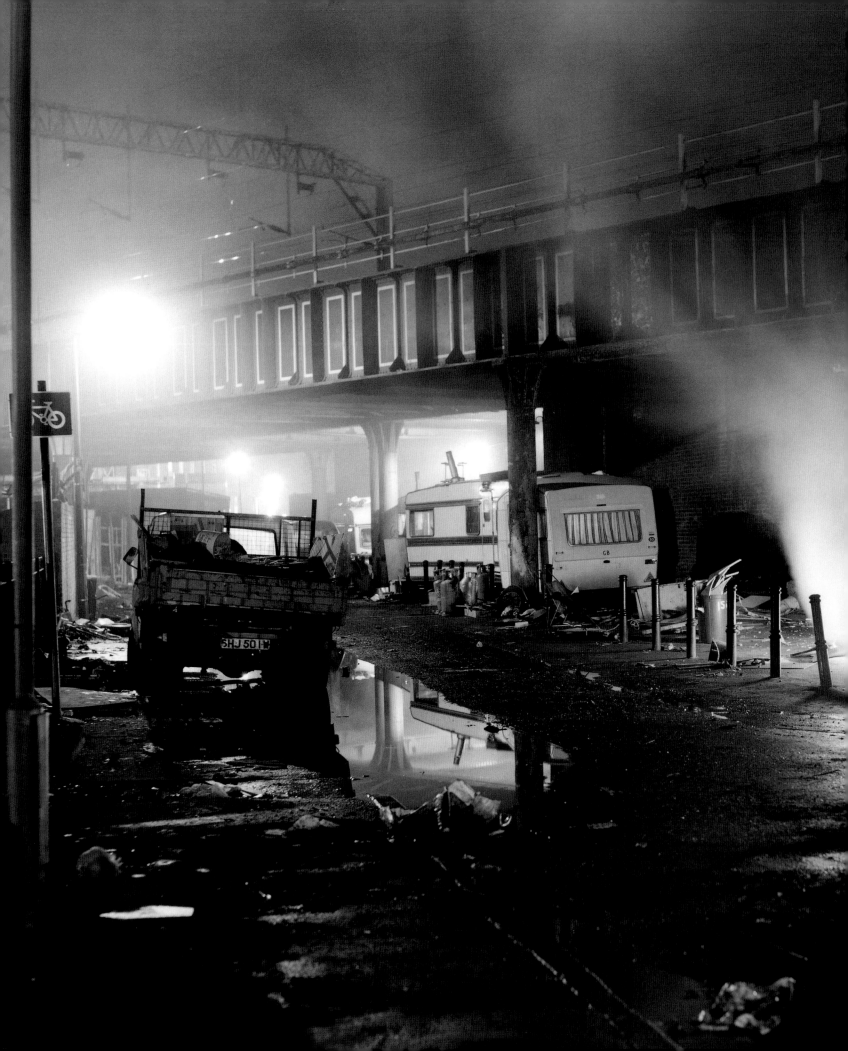

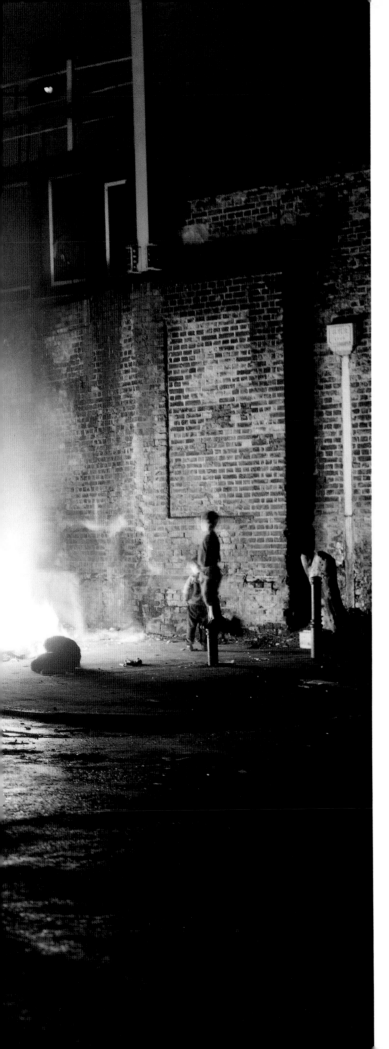

London Fields, Hackney

The name sounds like a contradiction in terms: there is little about the green space in Hackney called London Fields that evokes the countryside. Even in former centuries the sheep which grazed there had to search hard for a few tufts of grass in what was hard and dusty ground, or a swamp, according to season. Only highwaymen flourished. Martin Amis took *London Fields* as the title of his novel about the unleashing of destructive personal energies in what he portrays as the vicious urban jungle of inner West London. London Fields represents an imagined past to which one of the characters dreams of returning: 'I can see the parkland and the sloped bank of the railway line. The foliage is tropical and innocuous, the sky is crystalline and innocuous ...' In reality the railway bridge occasionally shelters the caravans of a few families of travellers who refuse to give up their traditional way of life.

Providence Yard,
Bethnal Green

'If you wish to have a just notion of the magnitude of this city,' Doctor Johnson told Boswell, 'you must not be satisfied with its great streets and squares, but must survey the innumerable little lanes and courts. It is not in the showy evolution of buildings, but in the multiplicity of human habitations which are crowded together, that the wonderful immensity of London consists.'

Jones Dairy opens on Sunday mornings to serve the flower market in neighbouring Columbia Road. In an area which used to house furniture workshops, small businesses are taking over. Now the tenants of local council estates are complaining bitterly about the amount of traffic and, on Sundays, the number of stalls, the noise and the parked lorries.

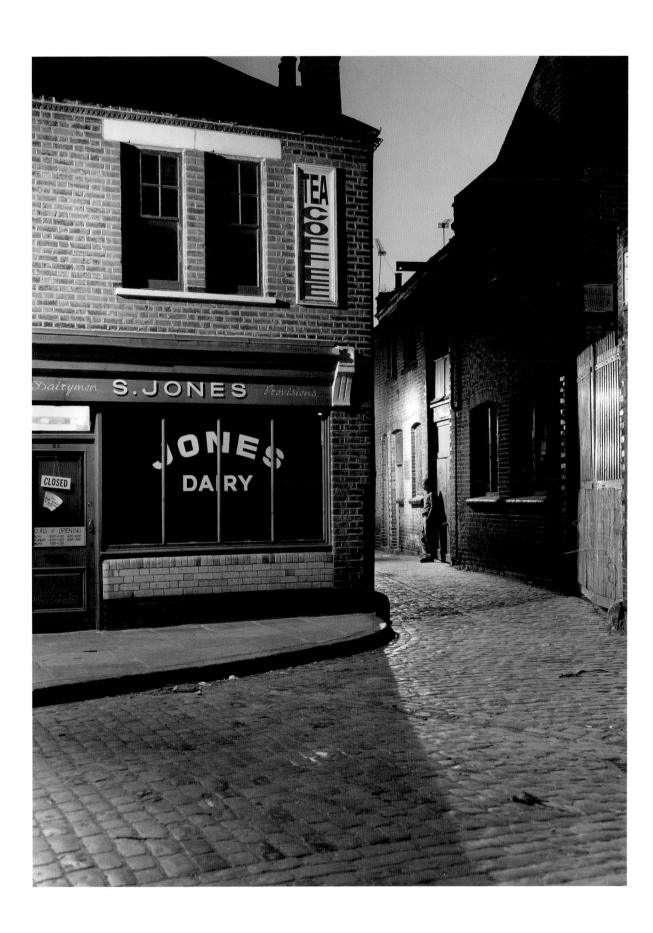

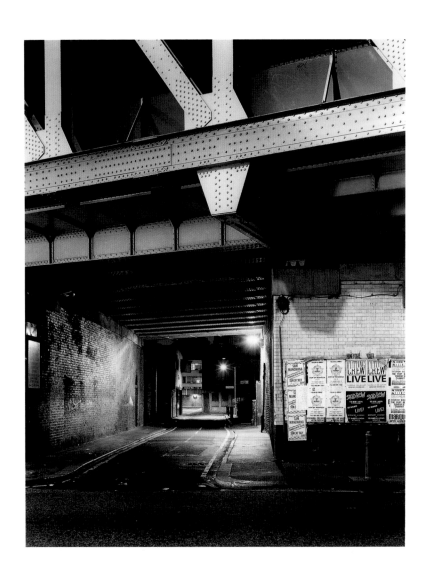

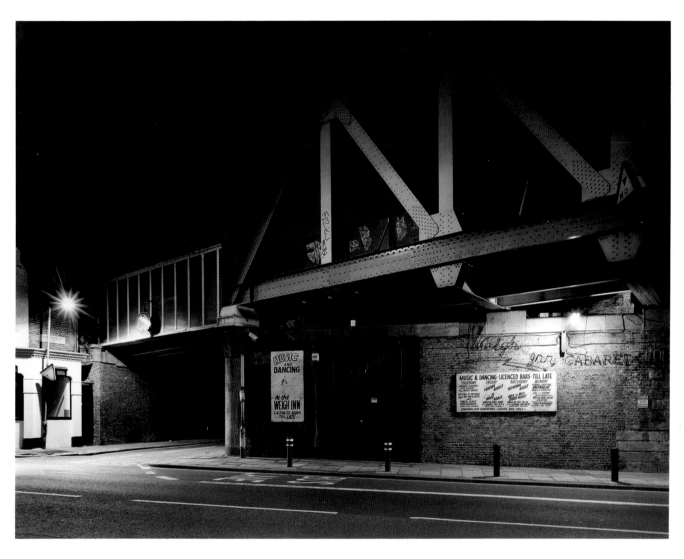

Kingsland Road,
Shoreditch

On four nights a week the Weigh Inn Cabaret Bar invites you to dance
to a disco or live music, or 'just relax in our lounge bar area: basket meals
available'. The name of the bar under the bridge refers to boxing, a sport
traditionally strong in Shoreditch. The bridge used to carry the North
London Line into Broad Street station, but the station is gone and the line
closed. Here it crosses two side streets and Kingsland Road, which the
Romans knew as Ermine Street, the main road leading north from
Bishopsgate.

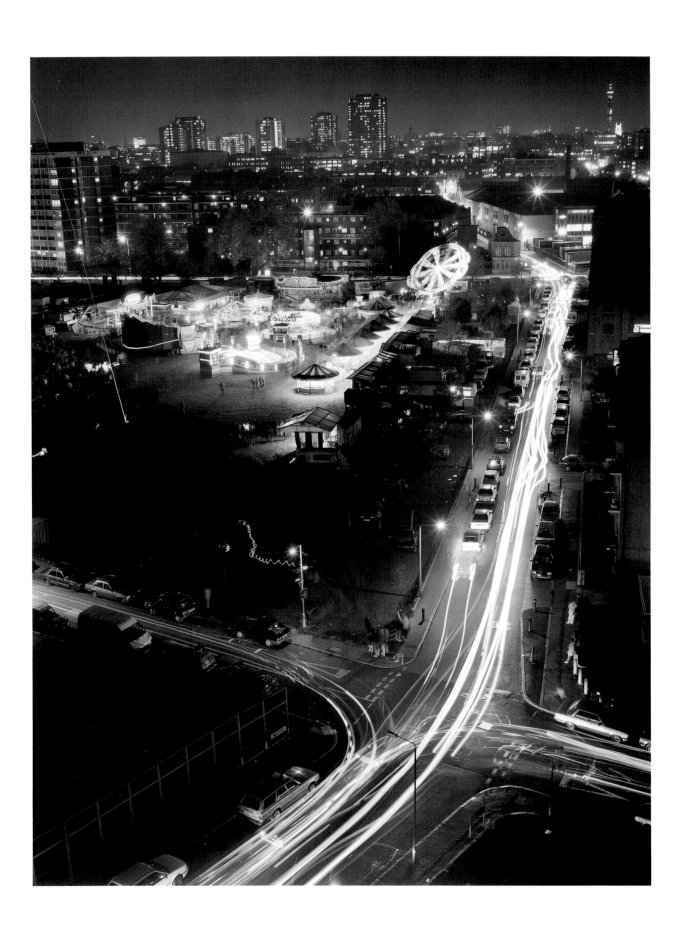

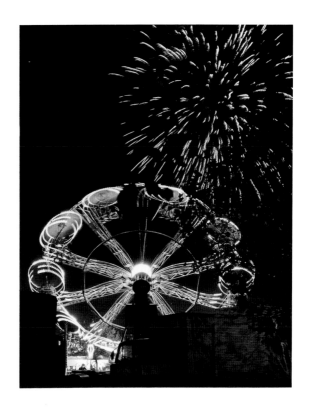

Funfair,

Shoreditch Park

On Guy Fawkes Night the camera has traced the paths of fireworks taking off. Things have changed since Wordsworth visited a London fair in 1802 and saw, as he recalls in *The Prelude*,

... Albinos, painted Indians, Dwarfs,

The Horse of knowledge, and the learned Pig,

The Stone-eater, the man that swallows fire,

Giants, Ventriloquists, the Invisible Girl,

The Bust that speaks and moves its goggling eyes,

The Wax-work, Clock-work, all the marvellous craft

Of modern Merlins, Wild Beasts, Puppet-shows,

All out o'-th'-way, far-fetched, perverted things,

All freaks of Nature, all Promethean thoughts

Of man; his dullness, madness, and their feats,

All jumbled up together ...

For more than a hundred years London's Jewish community has been moving slowly northwards from its original home in the East End. When the United Synagogue left its Leadenhall Street building (dating from 1760), it dismantled the interior and incorporated it into a new synagogue in Great St Helen's. The synagogue and its interior moved again, to their present location, in 1915. Stamford Hill's most striking feature is the large population of Hasidic Jews, whose long black coats and wide-brimmed fur hats have their origins in eighteenth-century Poland.

**United Synagogue,
Stamford Hill**
(previous pages)

Part of the landscape of industrial dereliction behind King's Cross and St Pancras railway stations, the gasholders owe their location to an earlier form of transport: the Regent's Canal carried the coal to the gasworks, which were built in 1824. The gasholder frames, perfectly combining industrial design and classical architecture, followed in the 1880s.

**Gasholders,
King's Cross**
(opposite and
following pages)

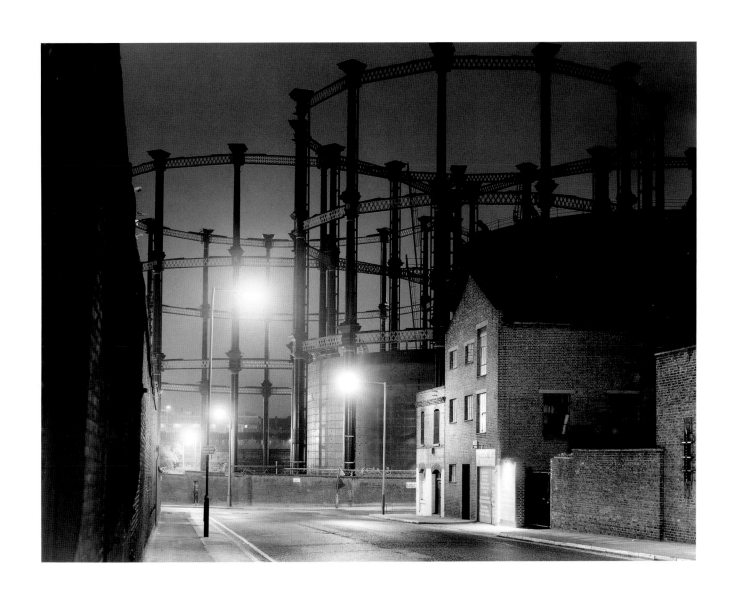

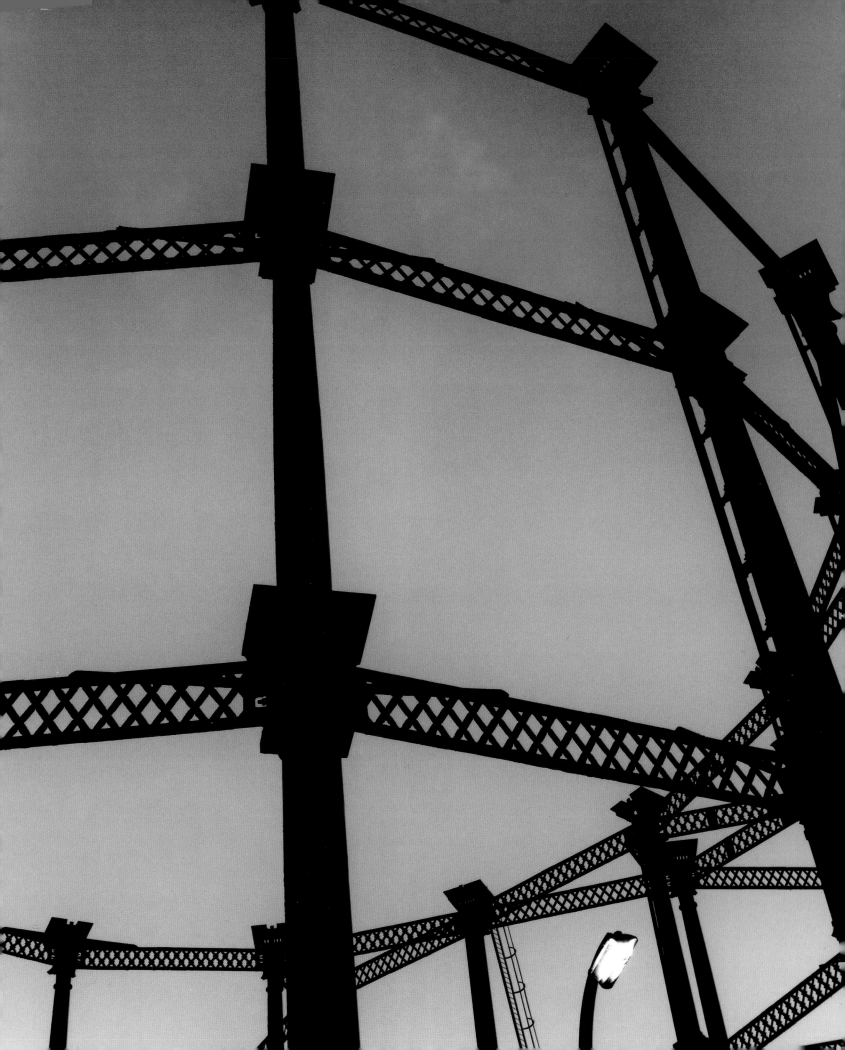

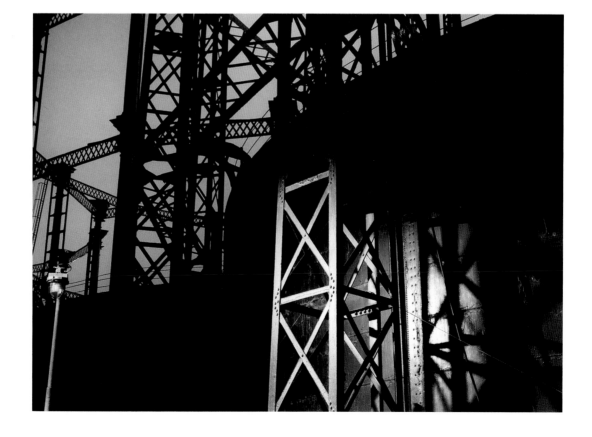

Much of the raw material for rebuilding London is brought up the river and washed, sorted and loaded on to lorries at waterside depots in Docklands. The development boom of the 1980s created a greater demand than ever, but it also transformed the depots into prime development sites and gave them neighbours for whom the romantic idea of Docklands living – in converted warehouses or nautically-themed apartments – did not extend to appreciating the life of a working river.

**Sand and gravel works,
Rotherhithe**

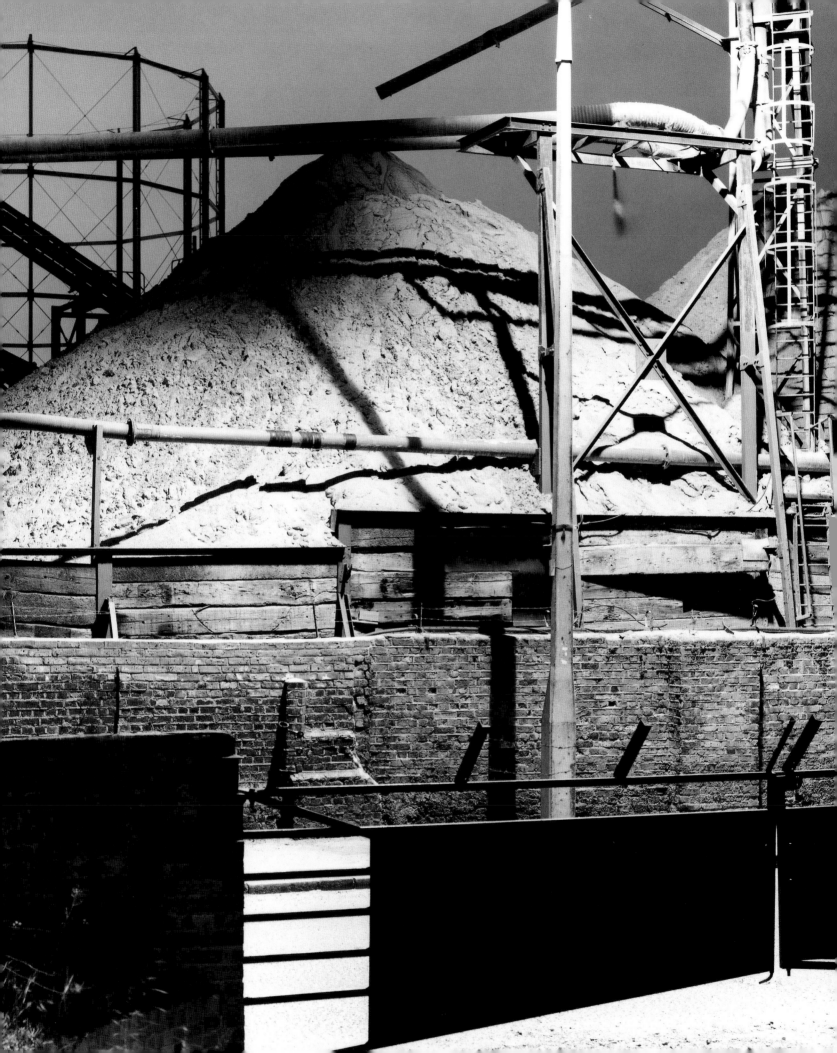

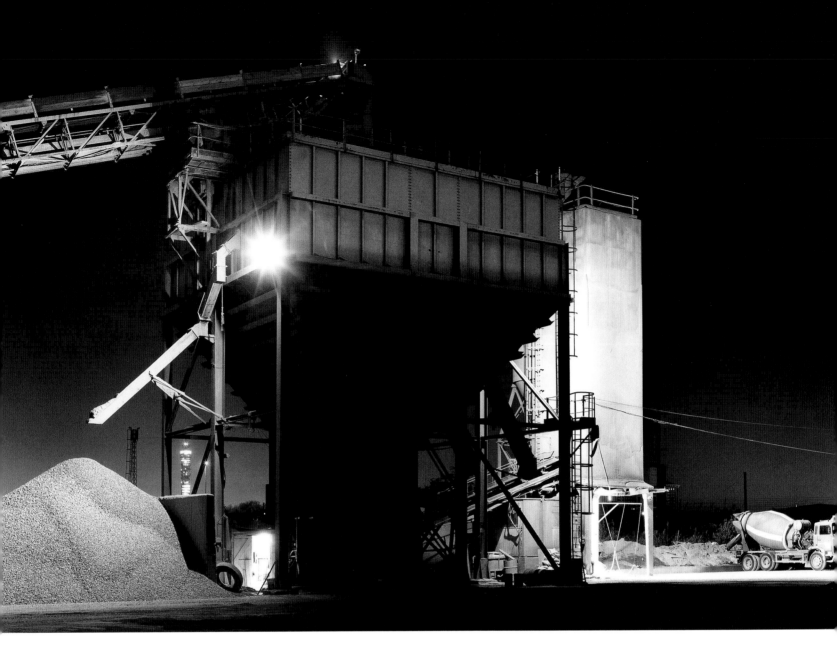

Concrete depot, The last functioning part of the King's Cross goods yard may spring into

King's Cross goods yard life if the area ever becomes the vast building site that has long been

anticipated.

Culross Buildings, built in 1891-92, represent the Victorian ideal of wholesome housing for the deserving working classes. Solidly built with all the charm of a barracks, they are tucked out of the way between the station and the gasworks.

Culross Buildings,

King's Cross

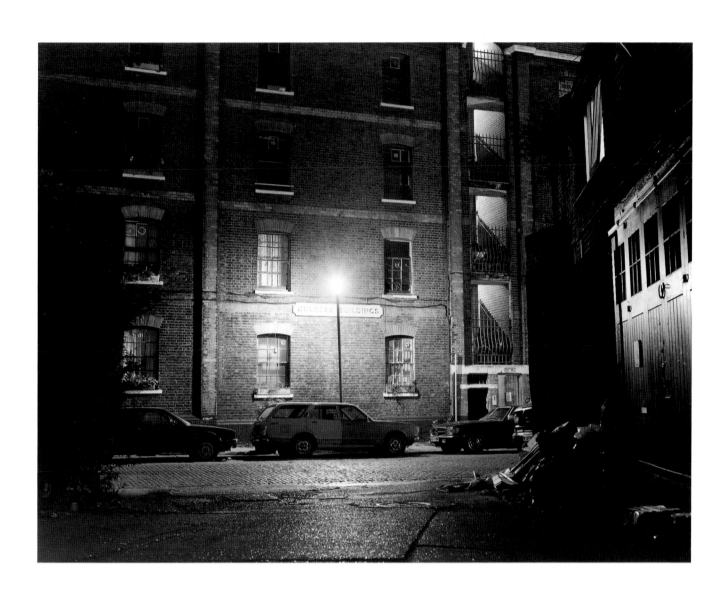

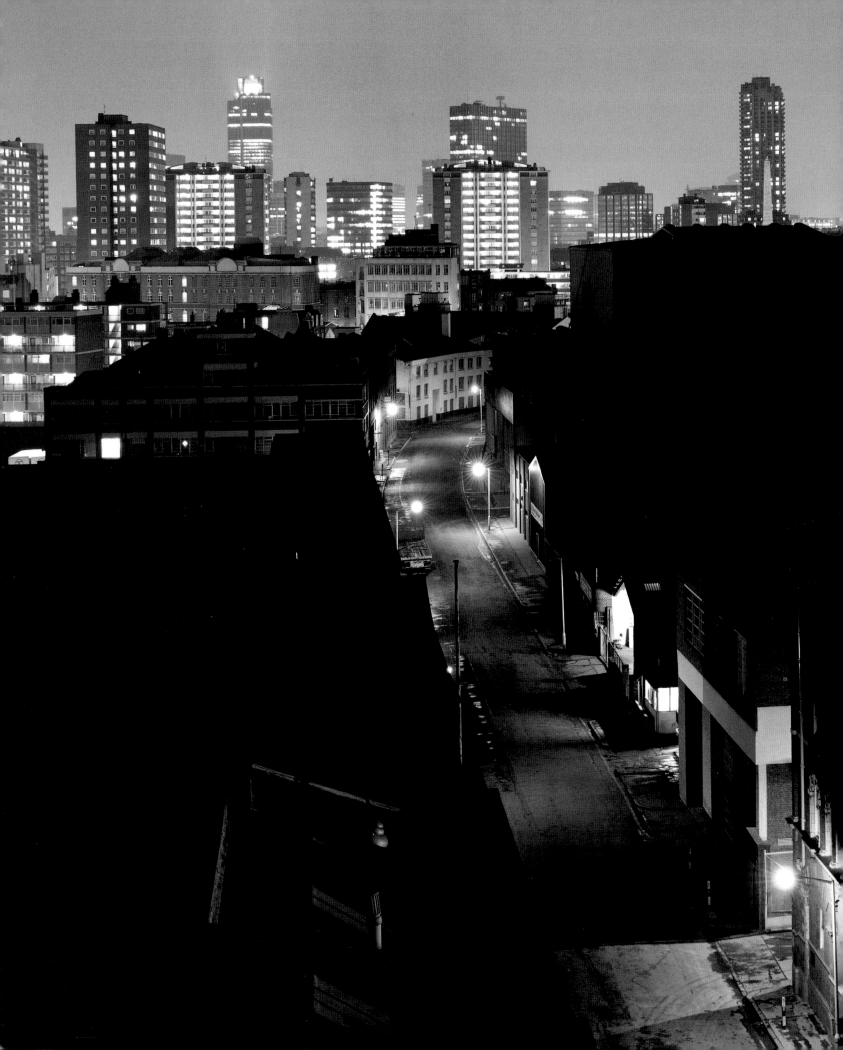

Wharf Road,
Islington

A view from Islington towards the City. Wharf Road is sandwiched between
two basins of the Regent's Canal – Wenlock Basin and City Road Basin –
as it leads south to City Road and the City of London beyond.

85

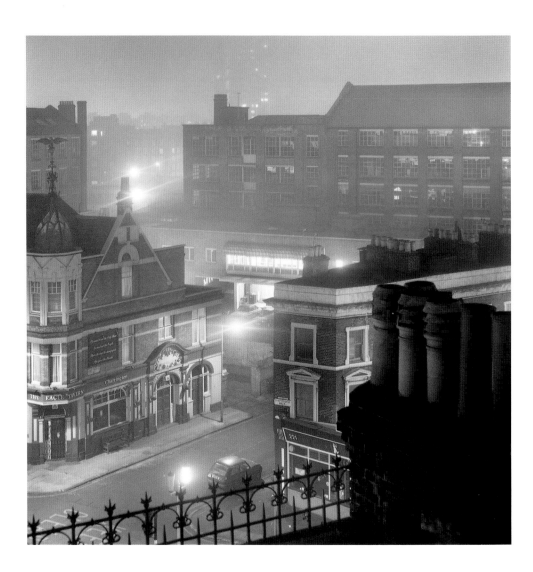

Up and down the City Road

In and out the Eagle

That's the way the money goes

Pop goes the weasel!

The Eagle, at the junction of City Road and Shepherdess Walk, stands on the site of the tavern immortalized in the nursery rhyme. An even earlier pub on the same site, the Shepherd and Shepherdess, refreshed sheep drovers on their way to market.

The young man in the song who goes 'In and out the Eagle' is apparently a tailor, dissolute enough to 'pop' (pawn) one of the tools of his trade the 'weasel' (a heavy pressing iron).

General Booth of the Salvation Army bought the Eagle in the 1880s to cleanse that sink of iniquity and provide himself with a headquarters. On examining the lease he was horrified to find himself forbidden from using the building for any purpose except selling alcohol. The old Eagle was replaced by the present building in 1901.

The Eagle Tavern,

City Road

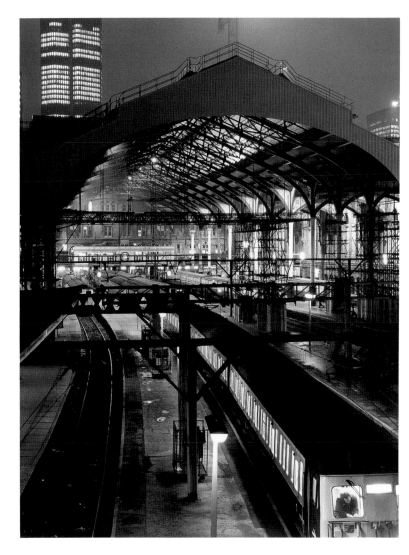

Liverpool Street station London's busiest railway station has been refurbished since this photograph was taken. It now finds itself enveloped by the Broadgate development, and this viewpoint has been swallowed by Exchange House. The Great Eastern Railway's terminus, designed by company engineer Edward Wilson, still has as much of the flavour of a cathedral as is possible in a building scoured by the tidal flows of City folk jostling their way from Essex to office and back. In its original state John Betjeman noted that 'the footbridge runs across in exactly the position one would expect to find the rood screen, and in place of the pulpit there are steps up to a first-floor buffet.'

Exchange House is a ten-storey office and dealing-room block suspended over the railway lines out of Liverpool Street station. Four giant parabolic arches in steel – 78 metres wide and eight storeys high, two within the building and two on the outside – help to support the steel structure and lift it clear of a landscaped plaza, which becomes a roof over the tracks.

Exchange House
under construction

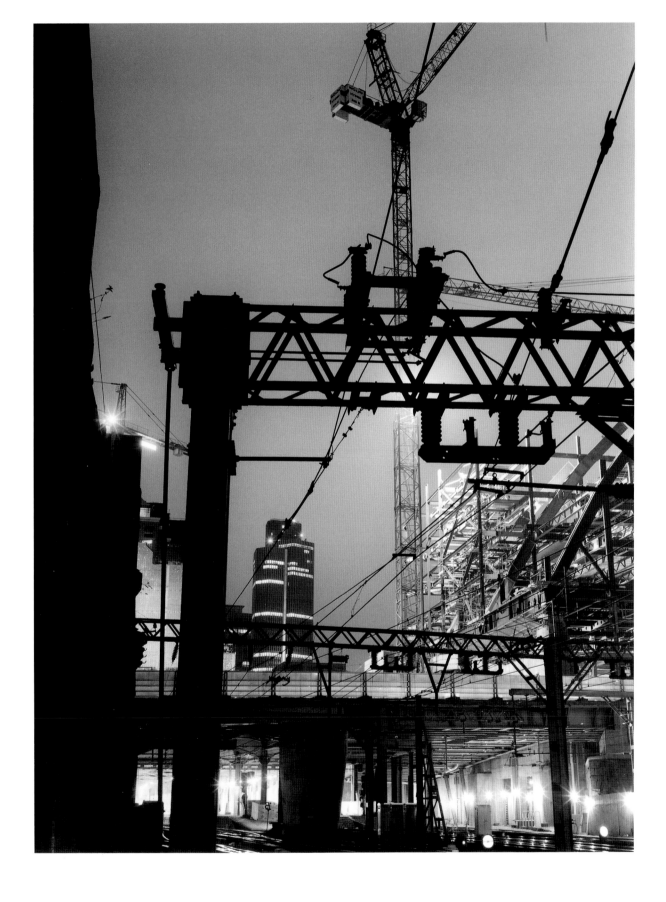

**Broadgate
under construction**

Until Spitalfields Market closed in 1991, wooden pallets on which fruit and vegetables arrived provided fuel for the all-night fires kindled by some of the area's homeless people. In the background looms part of the Broadgate development, marking the eastern frontier of London's office district along Bishopsgate. The contrast is striking. Broadgate is a 29-acre office city within a city, occupying the site of the former Broad Street station and swallowing Liverpool Street station whole. It exudes self-confidence: however rundown Spitalfields may be, Broadgate will offer the environment that business expects.

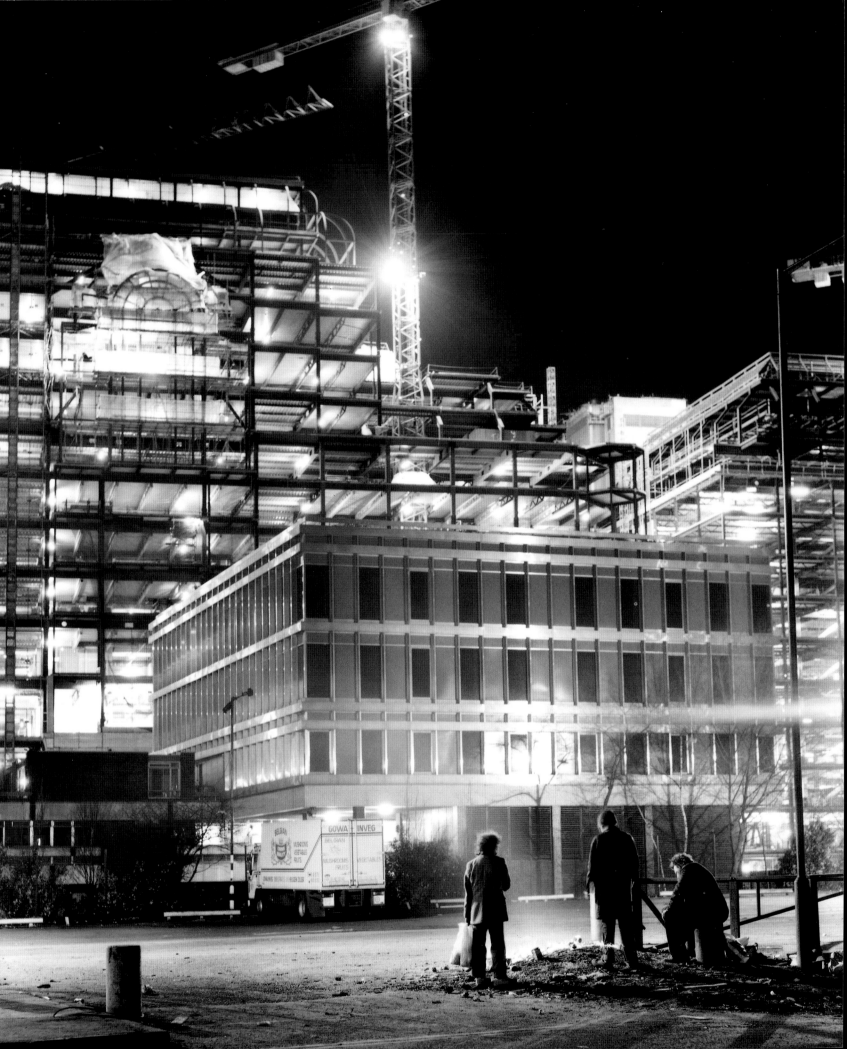

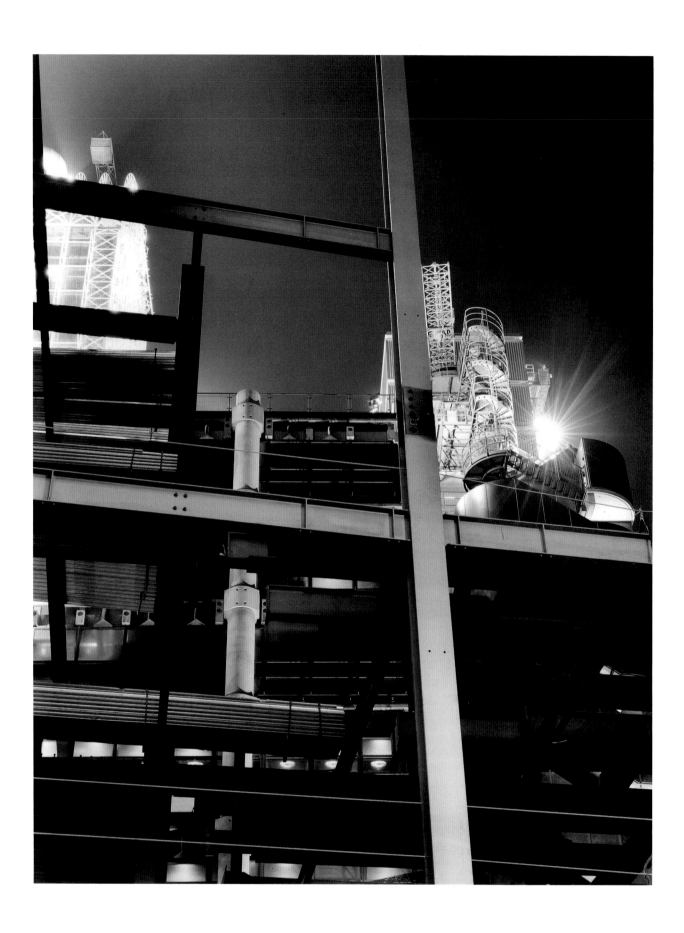

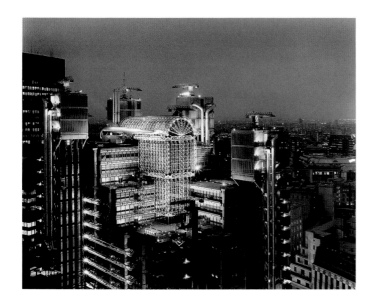

The Lloyd's building Sir Richard Rogers' masterpiece the Lloyd's building, seen opposite through a building under construction on Leadenhall Street, is one of London's few buildings designed to be a landmark at night. Its external lighting clothes it and emphasizes the dramatic shapes of pipes, atrium and service towers, while dimpled opaque glass makes the windows sparkle.

How strange that such an innovative building should have been commissioned by the most traditional of clients. But Rogers' strategy suited Lloyd's precisely because it offered the chance to carry on business as usual whatever changes in technology the future might bring. At the heart of the building is a huge multi-storey underwriting 'room' where 5000 people devote themselves to the serious business of making money.

Sewing machines in thousands of small businesses work late into the night in the East End clothing industry. Whitechapel, its traditional centre, is seen here in a view looking south-east from Commercial Street. Beyond lie Stepney, Limehouse and, under construction, Canary Wharf. Whitechapel had a long history of Jewish immigration, particularly in the three decades after 1880, but in recent years the Jewish community has largely been replaced by Bengalis.

Whitechapel

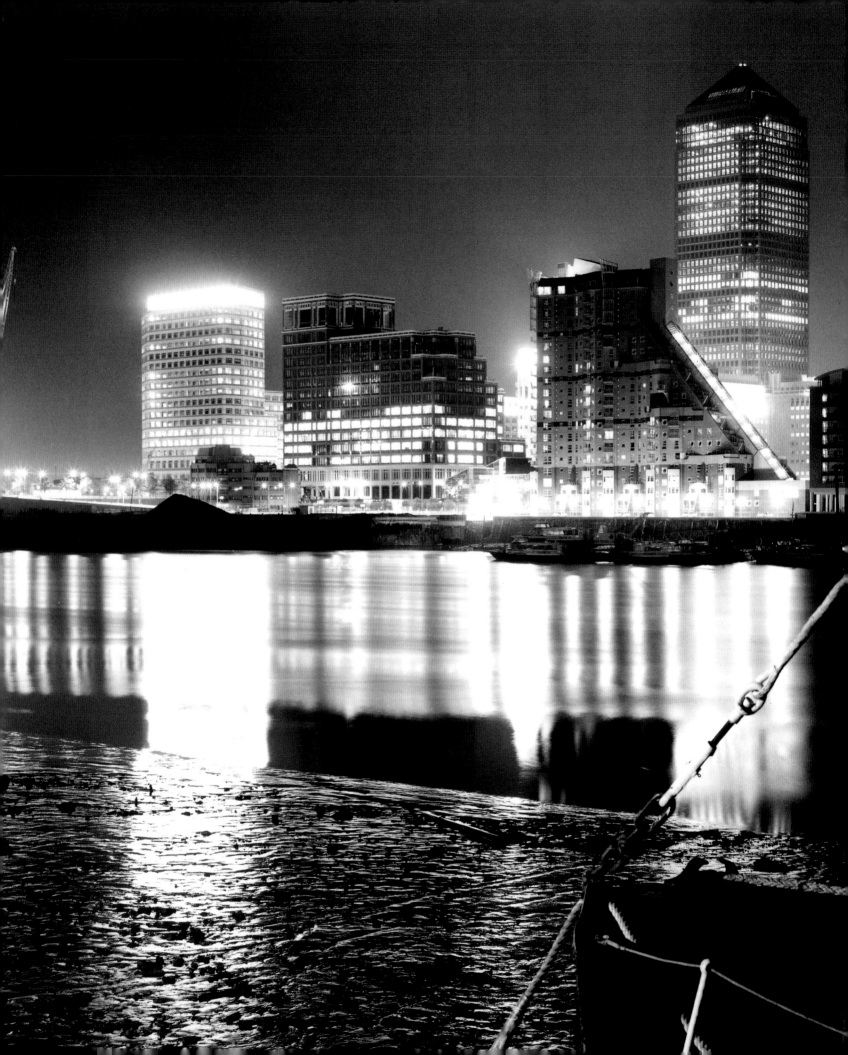

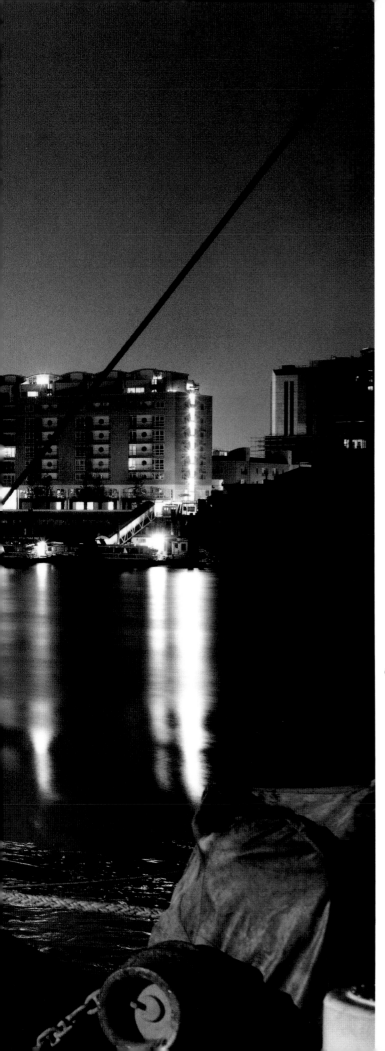

Canary Wharf

(left and following pages)

The sun has set on Canary Wharf. Of all the places to build an alternative financial centre to the City of London, the Isle of Dogs seems an unlikely one to choose. Its neighbours are the motley collection of buildings, ranging architecturally from the modest to the awful, which grew from the dereliction after the London Docklands Development Corporation was created in 1981, and the Isle of Dogs was designated an enterprise zone. Transport connections are hopelessly inadequate for the size of the development and there seems to be no scope for the sort of convivial urban buzz that the London financial markets still demand in the age of electronics.

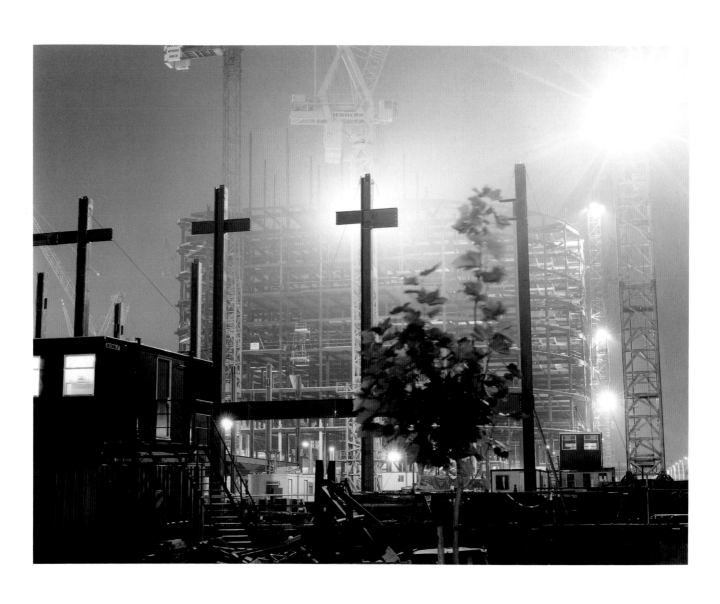

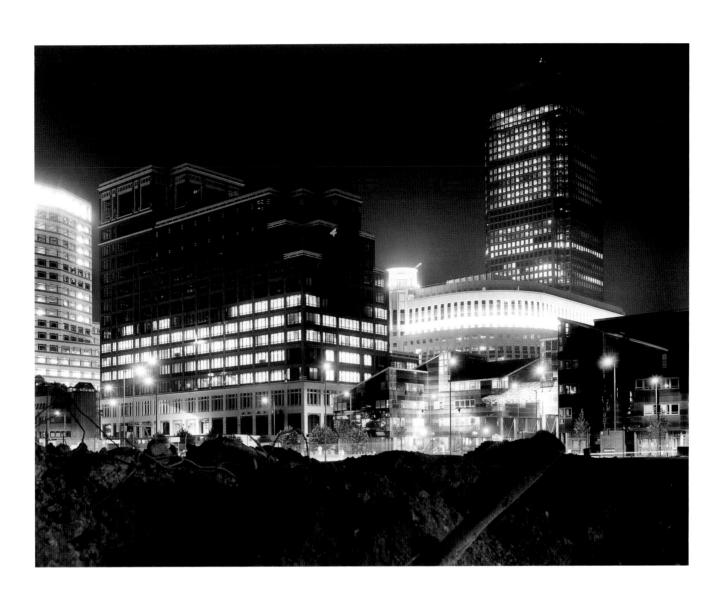

The Thames is less of a sewer than it was when Disraeli branded it 'a Stygian pool reeking with ineffable and unbearable horror', but its potential role in London's life has been neglected ever since the gradual closure of the docks, between 1966 and 1981. A glimpse of what the river once meant to the city as a great port is given by a contemporary list of just some of the cargoes which arrived in the Pool of London on one day, 17 September 1849 (the list excludes the coastal traffic, such as colliers, which tied up at riverside wharves):

32,280 packages of sugar from the West Indies, Brazil, the East Indies, Penang, Manila, and Rotterdam; 317 oxen and calves, and 2,734 sheep, principally from Belgium and Holland; 3,967 quarters of wheat, 13,314 quarters of oats, from Archangel or the Baltic; potatoes from Rotterdam; 1,200 packages of onions from Oporto; 16,000 chests of tea from China; 7,400 packages of coffee, from Ceylon, Brazil, and India; 532 bags of cocoa from Grenada; 1,460 bags of rice from India, and 350 bags of tapioca from Brazil; bacon and pork from Hamburg; and 8,000 packages of butter, and 50,000 cheeses from Holland; 900,000 eggs; 4,458 bales of wool from the Cape and Australia; 15,000 hides, 100,000 horns, and 3,600 packages of tallow, from South America and India; 13 tons of animal hooves from Port Philip, and 140 elephants' teeth from the Cape; 1,250 tons of granite from Guernsey; copper ore from Adelaide, and cork from Spain; 40,000 mats from Archangel, and 400 tons of brimstone from Sicily; cod-liver oil and 3,800 sealskins from Newfoundland; 110 bales of bark from Africa, and 1,110 casks of oil from the Mediterranean; lard, oil-cake and turpentine from America; hemp from Russia, and potash from Canada; 246 bales of rags from Italy; staves for casks, timber for houses, deals for packing-cases; 876 pieces of rosewood; teak for ships, logwood for dye, lignum vitae for ships' blocks, and ebony for cabinets; cotton from Bombay, zinc from Stettin; 1,000 bundles of whisks from Trieste, yeast from Rotterdam, and apples from Belgium; of silk, 900 bales from China, finer sorts from Piedmont and Tuscany, and 200 packages from China, Germany and France; cashmere shawls from Bombay; wine, 1,800 packages from France and Portugal; rum from the East and West Indies, and scheidam from Holland; nutmegs and cloves from Penang, cinnamon from Ceylon; 840 packages of pepper from Bombay, and 1,790 of ginger from Calcutta; 100 barrels of anchovies from Leghorn, a cargo of pineapples from Nassau, and 500 fine live turtles; 54 blocks of marble from Leghorn; tobacco from America; 219 packages of treasure – Spanish dollars, Syree silver from China, rupees from Hindostan, and English sovereigns.

Unload, transport, store, buy and sell, insure, trade and process those cargoes; feed, house, administer and educate the people who carry out those activities, protect them by law, nourish them by the arts and religion, and there you have the core of historic London.

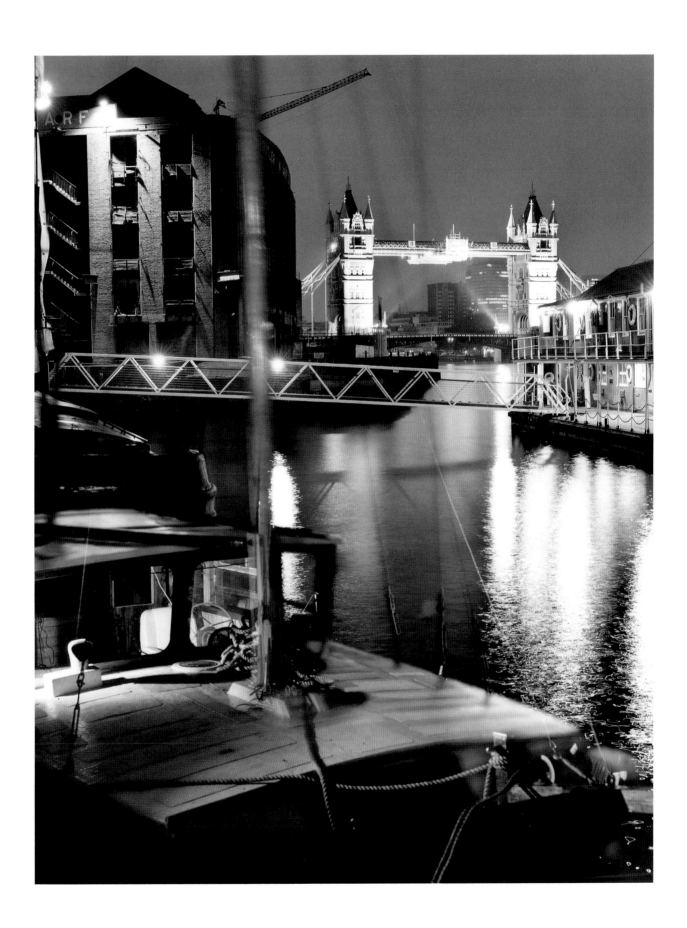

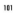

The threat of demolition that hung over Leadenhall Market little more than a decade ago has been lifted. The Corporation of London has repaired the fabric, renewed the rich Renaissance-style decorations and resurfaced the roadways with granite setts. Built in 1881, the market's traditional specialisms of poultry, fish and meat are augmented these days by shops and wine bars. Beauchamps is known for its sloe gin.

Leadenhall Market

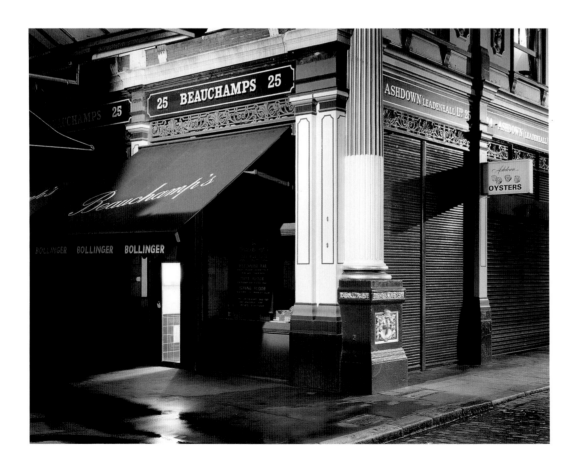

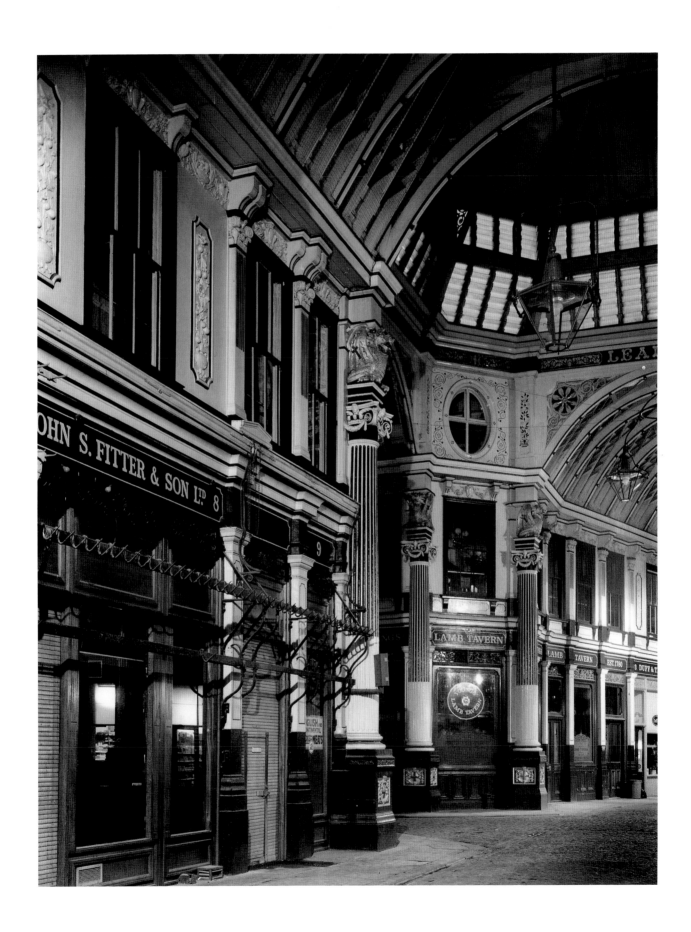

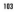

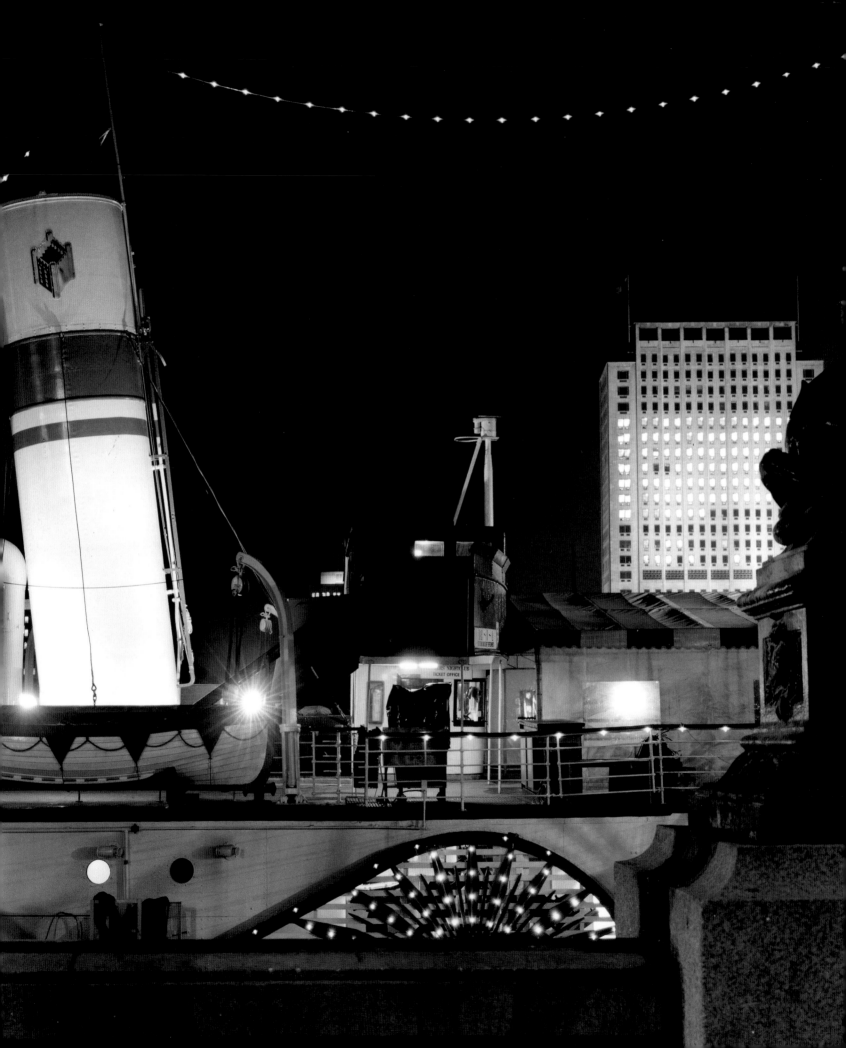

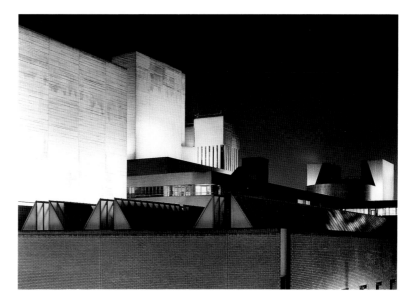

National Theatre

The floodlights emphasize the uncompromising blankness of the walls:
the concrete fly towers and lift shafts bear only the indentations of the
shuttering used in their construction and the streaks left by London's rain.
Like its neighbouring buildings – the Hayward Gallery, Queen Elizabeth
Hall and the Purcell Room – the National Theatre does not suggest that
the arts are anything but a very serious business. But as a complex
arrangement of three theatres, associated uses and internal public spaces,
Sir Denys Lasdun's building creates an appropriate sense of occasion.

Tattershall Castle,
Victoria Embankment
(opposite page)

The paddle steamer, *Tattershall Castle*, one of several ships moored
permanently by the Victoria Embankment, is in service as a nightclub and
restaurant. Apart from where it allows access to the ships, the Embankment
– built up to 20 feet above the high-water mark – effectively cuts off the
river from the people who could enjoy it.

English Heritage wants to give Centre Point the protection of official listing. Not on architectural grounds, presumably, as the building is aesthetically shoddy. On historical grounds, then? It is certainly a landmark in the history of property development, but Londoners have suffered enough. Centre Point is guilty of the crime, committed unrelentingly for 30 years, of stealing the pavement, rudely forcing pedestrians into the traffic of Charing Cross Road or down a smelly subway, and blasting them with vicious downdraughts.

Centre Point,
New Oxford Street

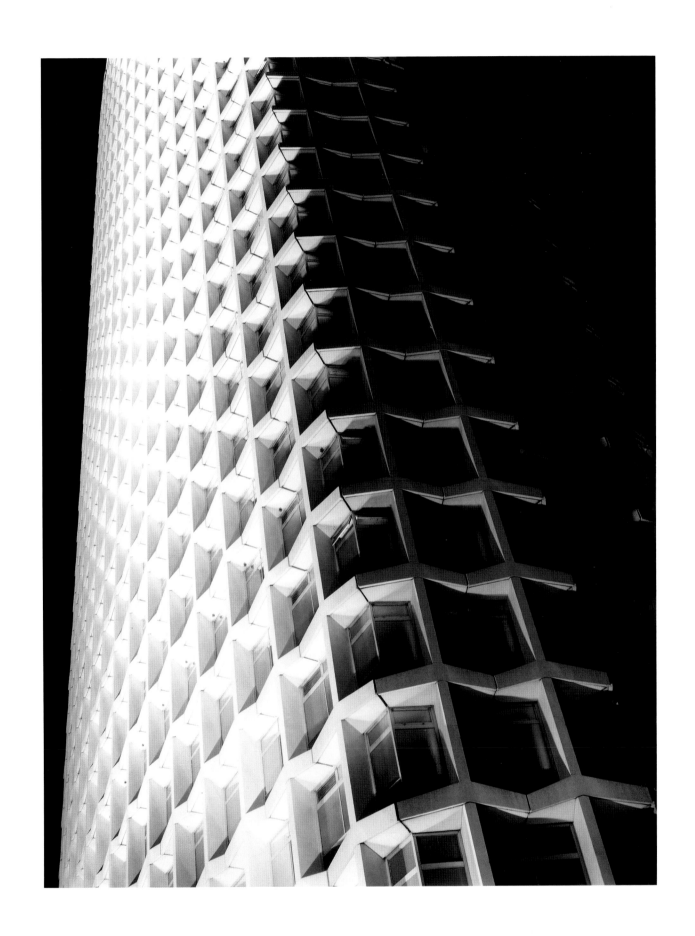

**St Mary-le-Strand,
Westminster**

At night St Mary-le-Strand enjoys some relief from the sea of traffic that normally engulfs it. James Gibbs knew that the church would be surrounded by tumultuous traffic (horse-drawn, of course, in 1714) when he designed it, and it has life and Baroque vigour enough to survive the visual assault of articulated lorries crawling by. But the vibration is shaking it to bits.

 Gibbs tried to protect St Mary-le-Strand from traffic noise by not providing any windows at groundfloor level. Today it is hard to imagine how noisy horse-drawn traffic could be. The architect H.B. Cresswell, writing in 1958, remembered when he was a young man in 1890: 'The Strand of those days was the throbbing heart of the people's essential London ... The streets of workaday London were uniformly paved in granite setts and the hammering of a multitude of iron-shod hairy heels upon them, the deafening, side-drum tattoo of tyred wheels jarring from the apex of one sett to the next like sticks dragging along a fence; the creaking and groaning and chirping and rattling of vehicles, light and heavy, thus maltreated; the jangling of chain harness and the clanging or jingling of every other conceivable thing else, augmented by the shrieking and bellowings called for from those of God's creatures who desired to impart information or proffer a request vocally – raised a din that is beyond conception.'

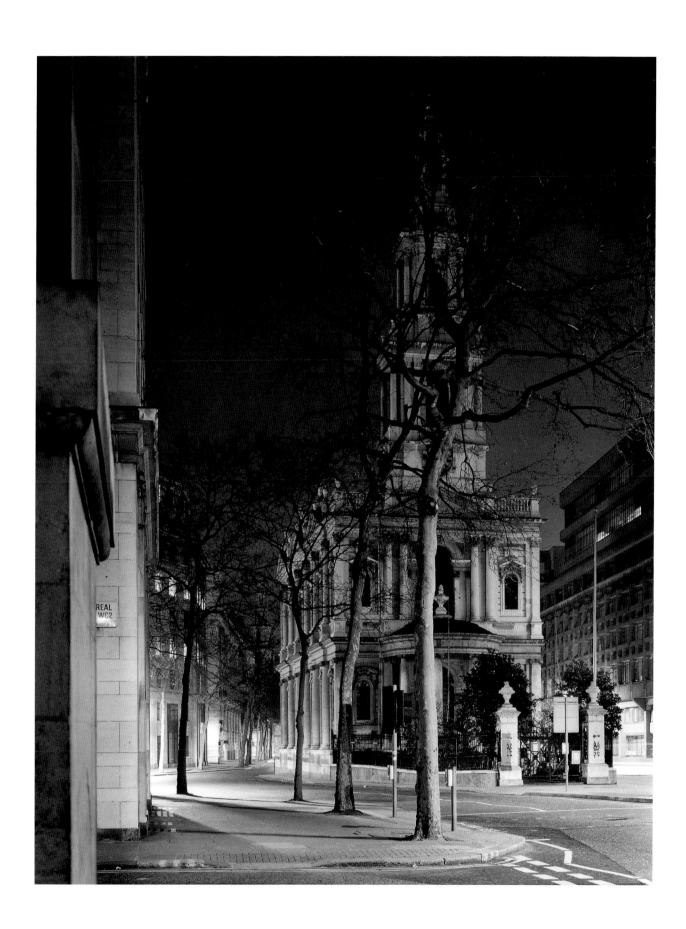

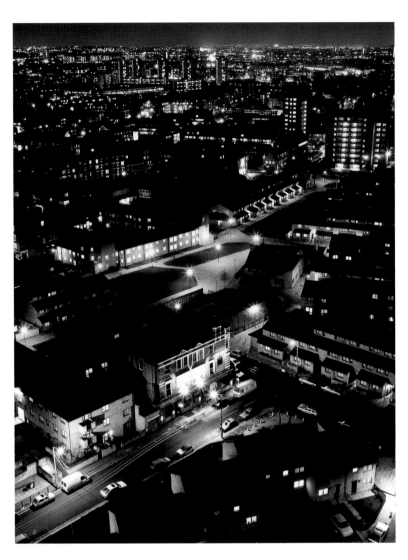

South of the Elephant

A vista of South London: a public house (the Hampton Court Palace) and, as far as the eye can see, public housing, built on sites provided by bombing or slum clearance. The view is from Elephant and Castle, with the five towers of Kennington's Brandon Estate in the distance. Such soulless sprawl fits many north Londoners' image of what lies south of the river: alien territory that they hope never to visit.

Heygate estate, Elephant and Castle

Bright lights and the luminous glow of glazed balconies; but the convivial streets in the sky that the architects thought they were creating became conveniently quick escape routes for burglars. The fashion nowadays is to demolish the walkways on council estates like this, but that often means that pedestrians have to use ill-lit routes at ground level instead, reducing the risk of burglary but increasing the chances of being mugged. The solution for many people is to stay locked up at home after dark.

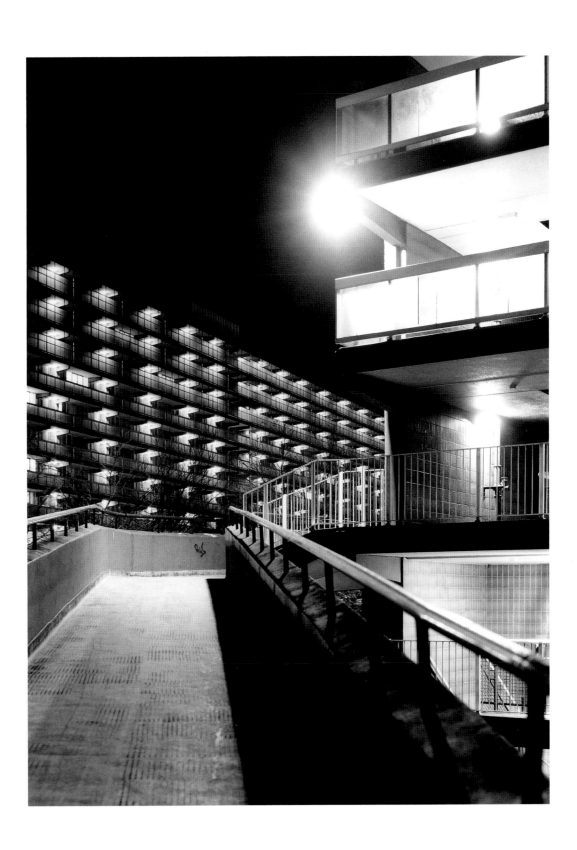

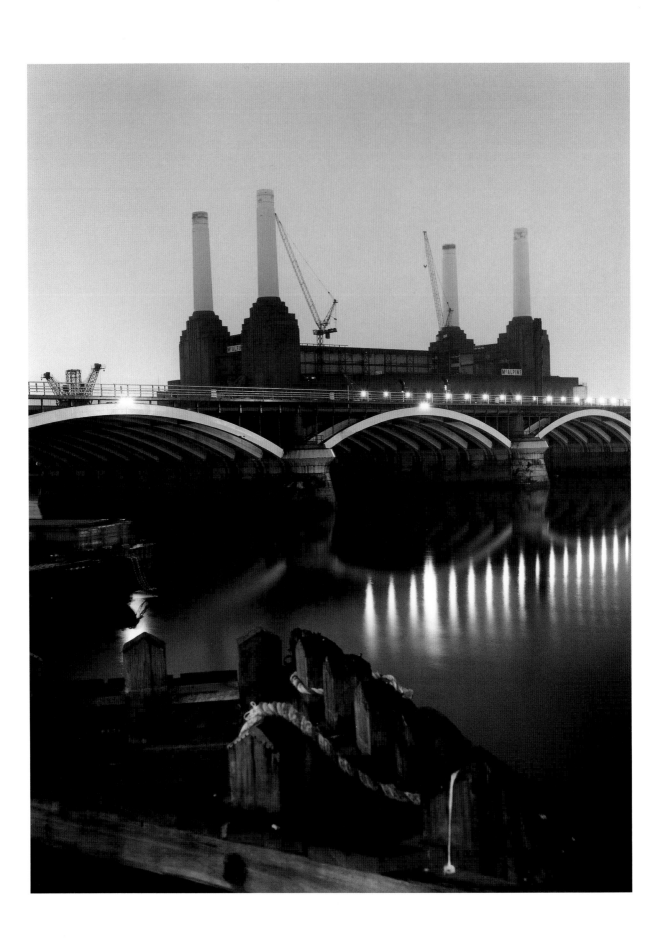

Battersea Power Station Ian Nairn wrote of 'immense plumes from the chimneys, lurid floodlighting',
but such scenes ceased when the power station was closed down in 1983.
Londoners retained an affection for the sleeping giant, and work began to
convert Sir Giles Gilbert Scott's 1934 listed building into a leisure and
theme complex. But the developer's money ran out and the roofless shell
now awaits some new scheme. The longer it lies empty, the more
passers-by can be heard wondering whether it is worth saving – and
the more conservationists and local campaigners are determined that
the failure of the original project should not be rewarded with permission
for the site to be cleared.

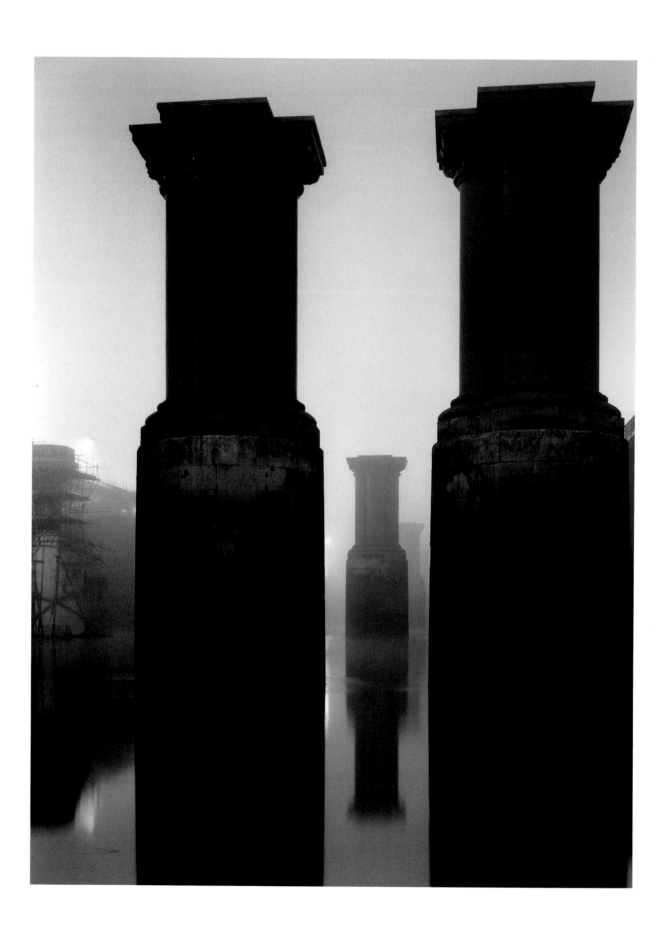

Bridges at Blackfriars

Massive Romanesque columns rise eerily from the Thames at Blackfriars. The bridge they once carried has gone, but huge cast-iron insignia at the abutments record that it was built in 1864 and carried the London, Chatham and Dover Railway. The monumental remains are flanked by Blackfriars Bridge (1860-69) and the replacement Blackfriars Railway Bridge (1884-86).

In this mood the Thames has seemed to would-be suicides a fitting place to end it all. Gaffer Hexham in Dickens' *Our Mutual Friend* had the grisly job of rowing a stretch of water downriver from here and fishing out the corpses. The eighteenth-century poet William Cowper arrived by coach at a spot not far from here to drown himself. It was one of his several unsuccessful suicide attempts: not only was the tide low, but he found 'a porter seated upon some goods there, as if on purpose to prevent me. This passage to the bottomless pit being mercifully shut against me, I returned back by coach.'

It was from Blackfriars Bridge that the body of Roberto Calvi, chairman of the Banco Ambrosiano, was found hanging on the night of 18 June 1982. He had been under pressure to explain his dealings with the Vatican Bank and the P2 Masonic Lodge, and the whereabouts of a missing $1.3 billion. Whether Calvi's death was suicide or murder remains a mystery.

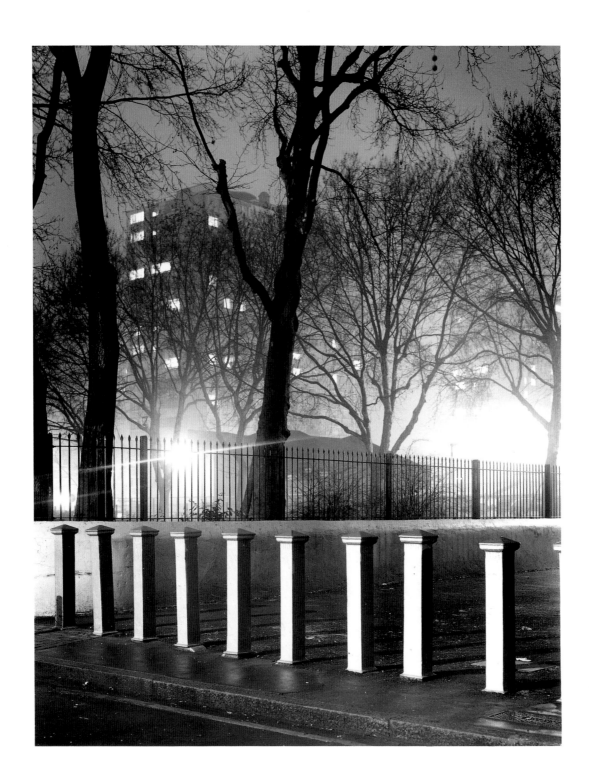

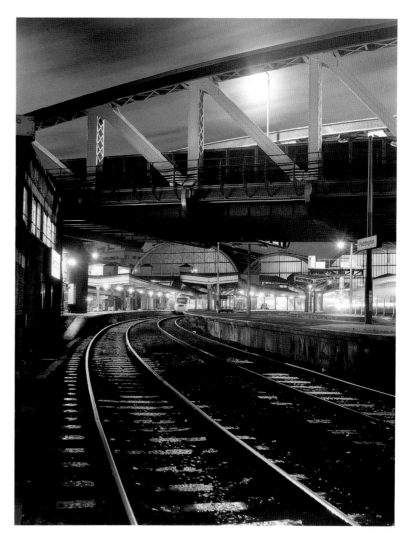

Paddington station

The first trains into Paddington station in 1854 ran on broad-gauge rails. Other railway companies used the narrower standard gauge but Isambard Kingdom Brunel, engineer to the Great Western Railway, refused to conform. His design for the station seems to combine inspiration from Paxton's Crystal Palace and Gothic cathedrals: the platforms are roofed as a nave and two rather lower and narrower aisles with transepts (the left-hand roof seen here is a later addition). The girder bridge carries Bishop's Bridge Road over the station and the adjacent Grand Union Canal.

Helmet Row, Islington

(opposite page)

The mist has come down on a damp autumn evening in Helmet Row. St Luke's Hospital, which used to stand near here, was opened in 1750 as one of London's first lunatic asylums. The ground is as unstable as the inmates were: the nearby St Luke's Church suffered from subsidence and is now a ruin.

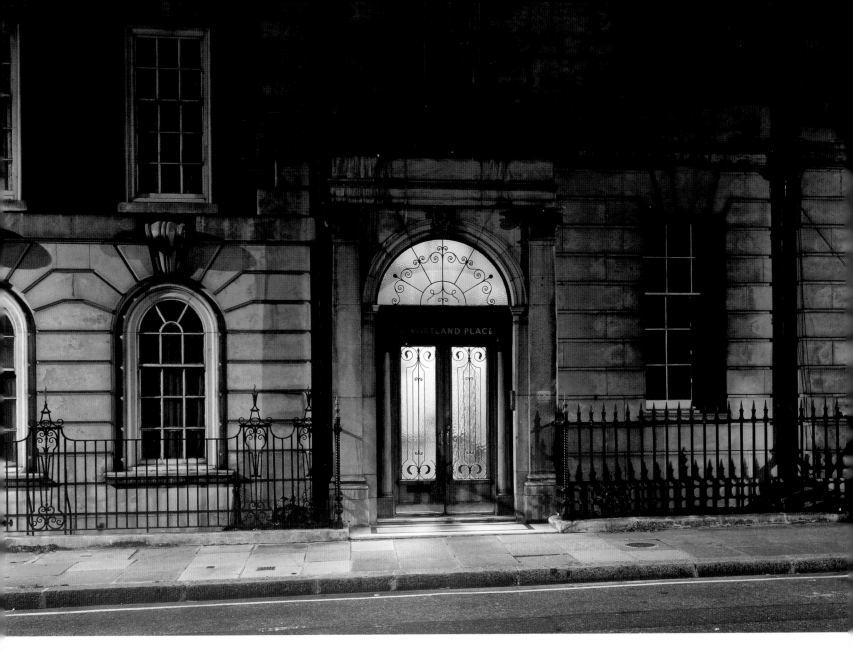

Weymouth Street Diplomats live here, handily just around the corner from the embassies in Portland Place. 119

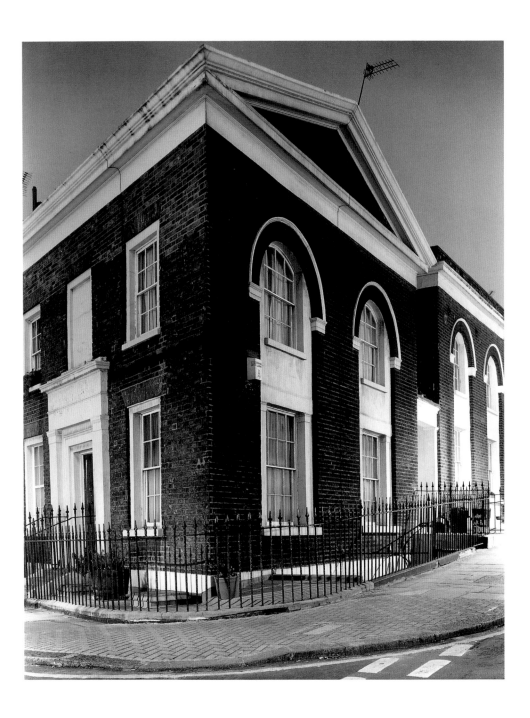

Lloyd Baker Street, Islington

The development of the Lloyd Baker Estate was begun in 1819 by William Baker and his son, Thomas Lloyd Baker. The lavishly pedimented houses were designed by John and William Joseph Booth.

Lloyd Baker Street leads into River Street, the former site of New River Head. This was the reservoir built in 1613 to supply water to the City of London following a plague epidemic. The New River was an extraordinary feat of engineering, bringing clean water 39 miles from Hertfordshire. From New River Head the water was carried to the City in wooden pipes, which in turn fed individual houses through lead pipes. The reservoir closed in 1946 after 333 years, and today the New River stops short at filter beds in Stoke Newington.

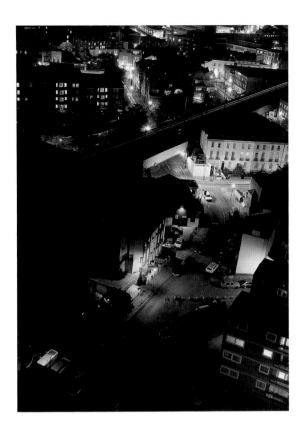

The North London Line
at Camden Town

London's first railway builders thought that their viaducts would be a social asset, with their arches occupied by houses and shops, served by a promenade. Instead the railways carved up the urban fabric and blighted the areas they passed through. Here the North London Line slices through Camden Town at St Pancras Way.

Camden Town
underground station

The last train has gone and Camden Town station is closing. The alcoholics who frequent it have been turned out for the night. Earlier in the evening a public address announcement gave its familiar message: 'If you are approached by anyone on this station, do not give them money. They only spend it on drink and assault our staff. The matter is in hand and the police will remove them.' This constant drama is augmented by the lively street life of the local market which attracts hordes of young people on Sundays.

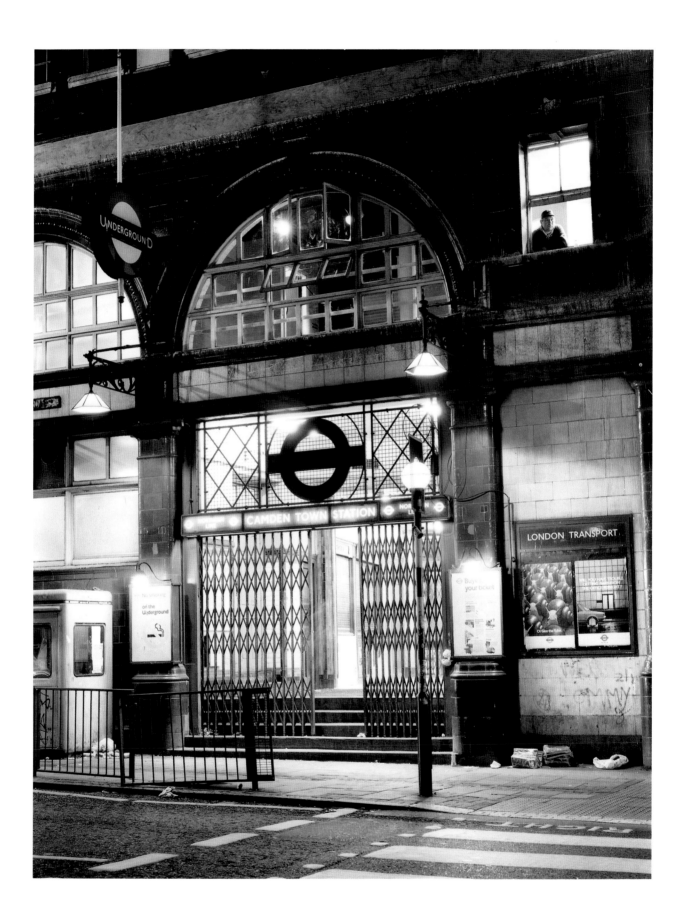

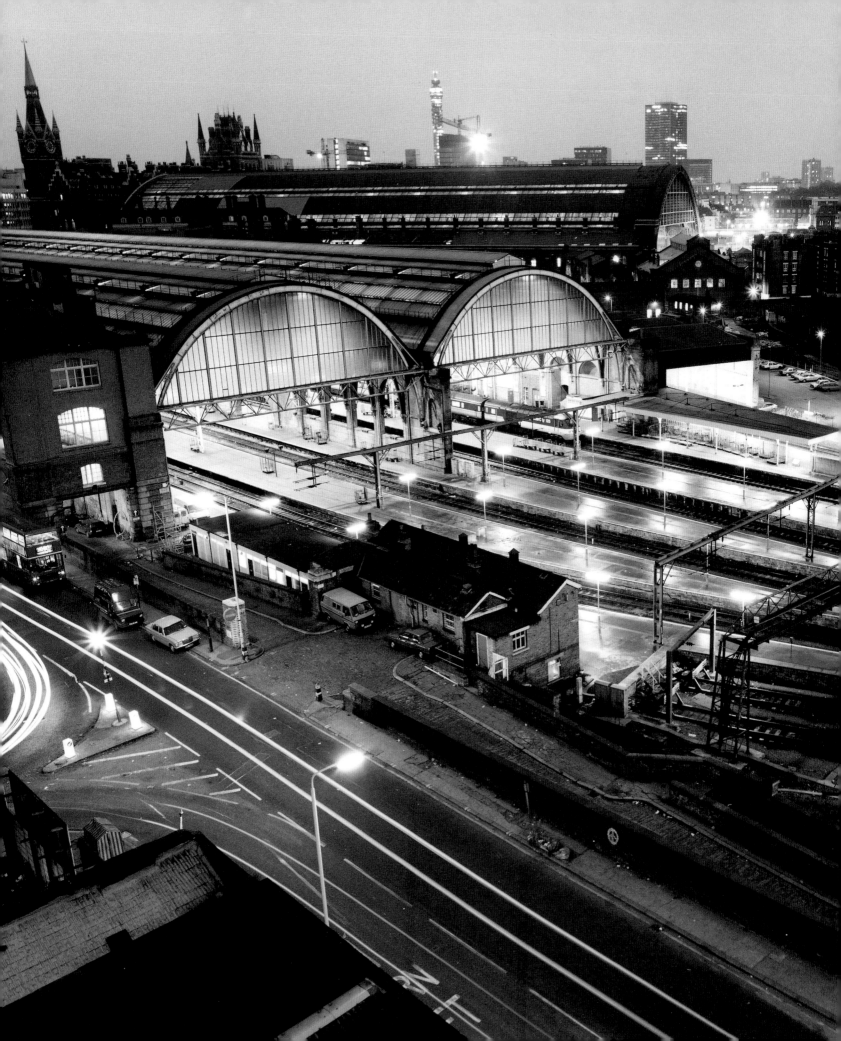

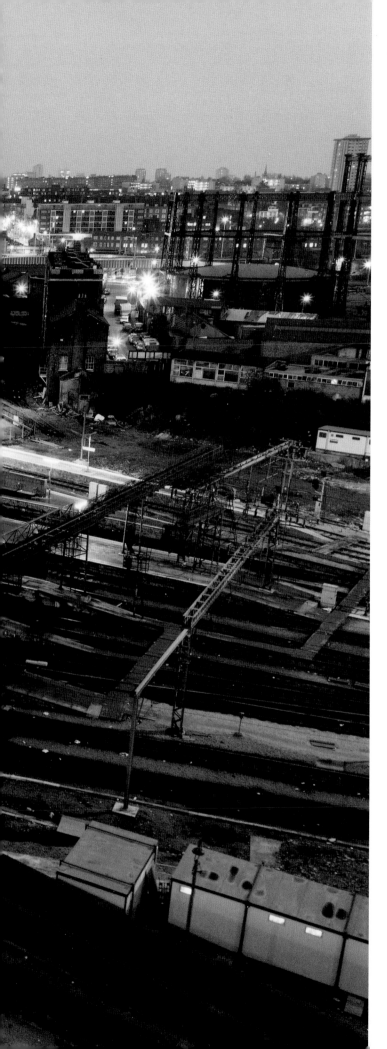

King's Cross station

'The building will depend for its effect on the largeness of some of the features, its fitness for its purpose and its characteristic expression of that purpose,' wrote Lewis Cubitt, the designer of King's Cross station. So successful was he in achieving that effect that some shareholders accused the Great Northern Railway Company – quite unjustifiably – of extravagance. Structurally it was not such a triumph: the roof's laminated timber ribs quickly deteriorated after the station opened in 1852 and they were replaced with iron.

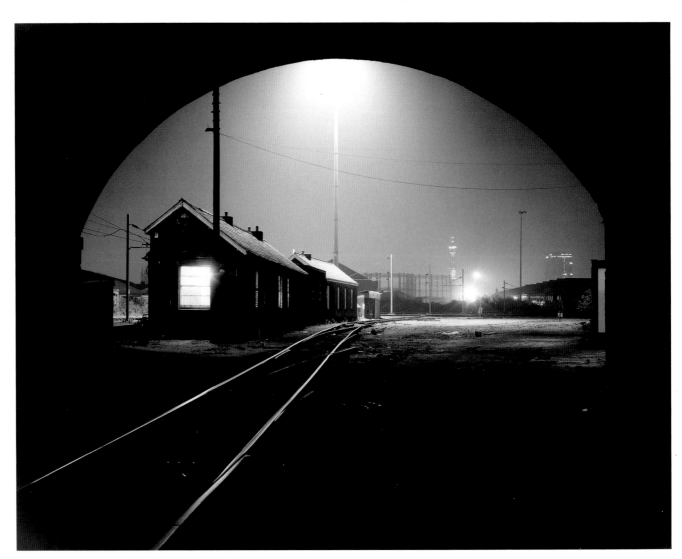

King's Cross goods yard In its heyday the 59 acres of sidings, sheds and warehouses of King's Cross goods yard transferred vast amounts of produce from the Great Northern Railway to horse-drawn wagons and canal barges. There was coal from South Yorkshire and the north-east, granite from Aberdeenshire, paving stones from Yorkshire, bricks from Bedfordshire, fish from Hull and Grimsby (taken from here to Billingsgate Market), grain, potatoes, turnips, peas, celery and cabbages.

Further reading

Hall, Peter *London 2001*, London, 1989

Hoggart, Keith and David Green (eds.) *London: a New Metropolitan Geography*, London, 1992

Kersh, Gerald *Night and the City*, London, 1938, republished London, 1993

Madox Ford, Ford *The Soul of London*, London, 1905

Nairn, Ian *Nairn's London*, London, 1966, revised edition 1988

Olsen, Donald J. *Town Planning in London: the Eighteenth and Nineteenth Centuries*, London, 1964

Pevsner, Nikolaus *The Buildings of England. London Volume 1: the Cities of London and Westminster*, 3rd edition, London, 1973

Pevsner, Nikolaus and Bridget Cherry *The Buildings of England. London Volume 2: South*, London, 1983

Raban, Jonathan *Soft City*, London, 1974

Rasmussen, Steen Eiler *London: the Unique City*, London, 1934, reprinted Cambridge, MA, 1982

Rogers, Richard and Mark Fisher *A New London*, London, 1992

Saint, Andrew and Elain Harwood *London*, London, 1991

Summerson, John *Georgian London*, London, 1945, republished London, 1991

Weinreb, Ben and Christopher Hibbert (eds.) *The London Encyclopaedia*, London, 1983

Acknowledgements

Robert Cowan wishes to thank Liz Cowan and Cy Fox for their help and support. Alan Delaney wishes to thank Peter Mackertich, Barbara Bellingham, Richard Haughton, Chris Gabrin, Andrew Cowan, Bernadette Garcia, and Cynthia, Richard and Kate Delaney. Alan Delaney's photographs are represented by Hamiltons Gallery and the London Picture Library.

127

Index

Page numbers in *italic* refer to the illustrations

35.00
10"